Science
&
Imagination

True stories from the Falconer Museum

Science & Imagination

True stories from the Falconer Museum

Edited by **CHRISTIANE H FRIAUF**
Published by **FRIENDS OF THE FALCONER MUSEUM**

First published in Great Britain as a softback original in 2022

Copyright of this anthology © Friends of the Falconer Museum

Copyright of each individual article including its images,
unless otherwise stated © the authors

All rights reserved.

No part of this publication may be reproduced, stored in a retrieval system, or transmitted, in any form or by any means, without prior permission in writing of the publisher, nor be otherwise circulated in any form of binding or cover other than that in which it is published and without a similar condition including this condition being imposed on the subsequent purchaser.

Design and typesetting by UK Book Publishing
www.ukbookpublishing.com

ISBN 978-1-915338-66-2

Cover photos: Hugh Falconer © Friends of the Falconer Museum/public domain
The Tortiphant, a sculpture by Dom Buxton © David Gordon
Ganesha, cup of tea © Claudia Dehio
Graphic support Bena Helle

Any mistakes in the historical accounts or other details conveyed in this book, as improbable as they may be, would have occurred because research in the Falconer Museum's archive was not possible during the creation of this anthology. The Friends of the Falconer Museum are happy to receive additional information on the topics of this book. http://falconermuseum.co.uk/

Berry Burn Community Fund kindly funded this publication.

Contents

Letter from the editor: About this anthology
Christiane H Friauf 1

MATTERS OF A MUSEUM

Stone heads, keystones, headstones:
The Falconer Museum sculptures in context
Dr John R Barrett 9

Three different species of humans:
An exceptional assemblage from an exceptional museum
Dr Torben B Ballin 21

The thing and the thing itself:
Teachings of the Falconer flints
By Ruth Fishkin 31

'What to bin and what to keep':
Museums as collective memory
Scott Keir 39

What are museums for?:
Thoughts on museums – and one in particular!
Norman Thomson 51

IN SEARCH OF HUGH FALCONER

A coat of many colours: Falconer, man and museum
Ruth Fishkin 63

A Who's Hugh of Aberdonian science:
Or: Dwarf elephants at the British Science Festival
Dr Victoria Herridge, 2012 69

Hunting for Hugh Falconer's notebooks in Forres...
A request for help
Dr Victoria Herridge, 2012 73

Founding father of the new science of palaeontology:
Hugh Falconer seen from an Indian perspective
Dr Vijay Sathe 77

For all the tea in China: A true tale
Anne-Mary Paterson 87

Connecting with our geological past:
Grace, née Milne, niece of Falconer, wife of Prestwich
Dr Alison Wright 91

Letters to a niece: Hugh Falconer in his own words
Christiane H Friauf 97

Bewilderment in managing pivotal Victorian research:
Dr John Grant Malcolmson, pioneer of early Scottish geology
Bob Davidson MBE FGS 103

IMAGINATION AND SCIENCE

A view from a tea garden
Jude Clay 119

The tortoise and the elephant
Jenny Mena 123

Elephant's head
Luca Brite 127

Letter from the editor

About this anthology

Christiane H Friauf

Why do Scots devote an entire museum to falconry? – That was my first question when I entered the remarkably decorated historic building called Falconer Museum. It was on one of my first days of visiting Forres, a town in the northeast of Scotland. I simply entered the old building to get a map of the area, as this impressive sandstone monument also housed the Tourist Office. A friendly elderly gentleman handed me my first map of Forres while I tried to peek around the wooden entranceway into the main hall, expecting daunting birds of prey, or rather feathery taxidermy on wooden perches, waiting in perpetuity for a falconer to train them. The hall at first glance appeared to be huge and airy, my neck grew longer, but still, I could not spot a single bird.

Instead, a huge tooth. A gigantic tooth. Had it not been gigantic, the reader might think, it was a trick of my imagination. What does a tooth have to do with falcons, I wondered. I took a mental note: Will have to come back and find out, even if I am not interested in falconry at all. As, to be honest, I was not.

With this anthology, the Friends of the Falconer Museum aim to help those who still wonder why the museum is named

as it is. The main aim of the essays, of course, is to discuss a multifaceted scientist, botanist, geologist, palaeontologist, an explorer who was representative for his era – and unique. With very few exceptions, the texts were written specifically for this anthology, celebrating 150 years since the museum first opened its doors, and the Friends are grateful for the time and effort that each author took in order to contribute to the cause.

It appears that Hugh Falconer, although famous while alive, is still relatively unknown today. One reason for this could be that there is no theory attached to his name, no invention, and no law. Even his involvement in the introduction of tea plants to India, crucial to outcompete the tea trade from China, did not make for an entry into our schoolbooks. Anne-Mary Paterson and other authors who shed light on Falconer's botanic endeavours in India, make it quite clear that there was smuggling involved. But would that be a reason not to mention him? Tea, by the way, features prominently throughout this book.

Falconer might have worked in too many fields of science to make a huge impression in one of them. We can suspect the main foundation for fame in pre-TV times lies in the written records. Unlike other explorers of the Victorian era, Falconer did not leave a legacy in form of an impressive number of articles or thick scientific volumes that later generations could refer to. He took countless field notes and wrote diaries, but they seem to have vanished, as Victoria Herridge points out in this anthology. Aware of the lack of written records of his work, colleagues and friends, soon after Falconer's death, assembled a wealth of notes in two volumes:

> Murchison, Charles 1868: *Palaeontological Memoirs and Notes of Hugh Falconer, with a Biographical Sketch of the Author.* Compiled and edited by Charles Murchison. 2 vols. London: Robert Hardwicke.

These books form an important source of information, but they are not easily accessible. And here is where this anthology steps in.

First, we take a closer look at the Falconer Museum itself, a building where "private philanthropy responded to the public thirst for knowledge", as John R Barrett reflects in his essay on the stone heads that adorn the façade. His engaging study offers a thorough analysis of architecture and decoration of this cultural monument. And more than that, he situates the conception of the Falconer Museum in the cultural and economic atmosphere of the Victorian era and its intricately connected scientific community. From there he draws the bow to recent worrying developments.

From the outside to the inside: Explaining the importance and relevance of the Falconer Museum's collections is easy, their status as tourist attraction with the highest possible rating undoubted, and the interest of researchers and other visitors from far and wide speaks for itself. Still, the findings that Torben B Ballin describes are mind-boggling: "With the artefacts from three lithic industries, visitors of the Falconer Museum can look at three different species of humans at once, *homo erectus*, *homo neanderthalensis* and *homo sapiens*." Ruth Fishkin shares the story of her unexpected encounter in the museum store with 250,000 years old hand-axes, still "carrying the mud of St Acheul", the world-famous archaeological site. She wonders: "What else is there that can be held in the palm of the hand and has roots this deep in us?"

Memory as a morphing experience is at the heart of Scott Keir's essay in which he discusses the intricacies of "what to bin and what to keep". Museums struggle to accommodate growing collections, while we constantly adjust "the lens through which we look at the past". Norman Thomson joins the conversation about museum's canon and heritage, concepts that are in constant flux. Like other authors in this anthology, who honour the immense importance of volunteer

work, he also advocates professional staff, because museum collections cannot be adequately looked after without "the intelligence, experience, and powers of discretion of a skilled individual as curator".

Next, the man behind the museum comes into focus. Authors Ruth Fishkin, Victoria Herridge and Vijay Sathe study Hugh Falconer from different angles, fostered by their individual academic backgrounds and work experiences. Vijay Sathe for example honours his colleague as the founding father of the palaeontology of India, drawing from deep knowledge of the academic life in his home country India, and from weeks of research in the Falconer Museum in 2019. As already mentioned, Anne-Mary Paterson makes no secret of the smuggling of tea plants from China to India, an affair in which Falconer played a significant part.

If at some point in the past, readers got frustrated with the apparently never-ending stream of male scientists in the written record, they may rest assured that this anthology did not forget about the women. There is a lot of information on women scientists waiting to be dug out, as you would expect in an archaeological or even palaeontological context. At a time when women were still denied access to higher education, Grace Milne, Hugh Falconer's niece, was encouraged by her uncle to study geology, and in later years she published articles and books. Alison Wright tells her story, observing how rapidly scientific thought developed "through the Victorian age, establishing frameworks that later discoveries have embellished but not fundamentally changed".

We come to ponder at what point in time Falconer adopted the idea of evolution. Contrary to the common assumption that Darwin's epochal *On the Origin of Species*, published in 1859, caused Falconer to turn away from the still widespread belief of Creationism, I would argue that letters to his niece, like the ones to be found in this anthology, show an earlier recognition of evolution.

Another important protagonist in the scientific arena of this time who, like Falconer himself, belonged to what John R Barrett laconically calls the "Scottish/Indian/naturalist circle", was surgeon and geologist John Grant Malcolmson, also from Forres. Malcolmson, beside his many other accomplishments, became famous for his finds of beautifully preserved fossil fishes at Lethen Bar in Nairnshire. How the information about these exciting finds made its way into the scientific world and beyond is subject matter for a detective investigation. Bob Davidson gives a summary of the events, not forgetting to mention eminent collector and supporter of the, then still young, science of palaeontology, Lady Eliza Maria Gordon-Cumming.

The moment the Falconer Museum opens its doors to the public again, the Friends of the Falconer Museum will continue to support exciting exhibitions, and there will be a special focus on women in geology and other sciences. One of the Friends' many endeavours in the past was the acquisition of the 'Tortiphant', the sculpture of the world-bearing tortoise-riding elephant of Indian cosmology, inspired by a contemporaneous caricature of Hugh Falconer and sculpted in 2018. It is at present the youngest addition to the museum's portfolio and can be seen on the book cover. Those who wish to learn how the Tortiphant really came into existence, will find the story in this anthology, narrated by Jenny Mena.

Three literary pieces conclude this volume, each in its own way inspired by Falconer's findings and the width of his interests, ranging from botany to mythology. Undoubtedly, science worked as the motivating force here, inspiring the creativity of authors Jude Clay, Luca Brite, and aforementioned Jenny Mena. India, the country of Falconer's many important discoveries, is their joint point of reference, while each follows her imagination in a unique way.

While I have been wearing the editor's hat, other committee members of the Friends of the Falconer Museum

diligently worked in the background. Without Alison Wright, Christine Clerk, John R Barrett and Ruth Fishkin, this anthology would simply not exist. My heartfelt thanks also go to Ruth Lunn and Jay Thompson of UK Book Publishing who, throughout the process, made the production of an incessantly evolving publication appear like a breeze.

May this joint effort bring joy and the sense of wonder to its readers, in addition to the treasure of information. In any case, it provides some good answers to the question why museums matter.

About the editor

Christiane H Friauf is a historian, non-fiction author, and editor. In a previous life in Germany, she published numerous books and articles, including on culture history, visual art, and literature. Since her recent relocation to northeast Scotland, the cultural as well as the physical landscape of this special part of the world draw all her attention.

MATTERS OF A MUSEUM

Stone heads, keystones, headstones

The Falconer Museum sculptures in context

Dr John R Barrett

The Falconer Museum in Forres first opened its doors to the public on 1 August 1872. The museum was founded in an age of optimism. Imperial expansion, industrial development and tentative democratisation all promised a future of peace and prosperity. Meanwhile, scientific advances challenged established certainties by revealing the astonishing complexity of Creation.

The museum is the Victorian age set in stone. In the 1860s free universal public education lay some time in the future; but private philanthropy responded to the public thirst for knowledge. The wealth that Hugh and Alexander Falconer earned from commerce and colonial enterprise laid the foundation for a museum in their home town. Public subscriptions added an income to underwrite running costs. The list of subscribers mirrored Forres society: landowners at the head and a fat body of farmers and burgesses gave £5; a long tail of shopkeepers and ordinary folk were tiered into a half-guinea middle class and a five-shilling lower order.

Meanwhile, the individual generosity of Moray's dynamic antiquarians, anthropologists, botanists, geologists, and naturalists established the foundation collections of a cabinet of curiosities that brought the wide world home and history to life for the people of Forres. And Hugh Falconer's own contributions – including precious fossils from the Siwalik Hills of northern India and Palaeolithic artefacts from St Acheul in France, worthy of being cared for in national museums – form an original treasure among collections that attract scholars from across the world.

Moray's leading architects, Alexander and William Reid, were commissioned to design the new museum. The Reids inherited the architectural flair of their uncle, William Robertson: designer of the sturdily vernacular Forres Tolbooth, the airily classical Anderson's School, and the politely elegant Cluny Cottage which Hugh Falconer's geological friend J. G. Malcolmson intended for his retirement. A site was cleared in the centre of town, by demolishing several charming seventeenth-century buildings at the head of Tolbooth Wynd. The Reids fitted an Italian Renaissance *palazzo* onto the plot. The style chosen for the new seat of learning in Forres reinforced a slender Italianate thread that dignified the architectural fabric of west Moray: for example St John's church in Forres and the sprawling home farm at Altyre. The glorious ebullience of the Falconer was perhaps intended to eclipse the sedately tasteful Italianate rival museum in Elgin. The original design for the Falconer included a campanile – a usual accoutrement of the Victorian Italianate. Sadly, this crowning glory proved unaffordable; and the museum, as built, wears its decorative excesses with a demure modesty, as though embarrassed by its unfinished, towerless condition.

Dr Hugh Falconer, physician, botanist, palaeontologist, archaeologist, philanthropist, was elevated to preside over the High Street façade of the museum he founded. The Falconer

bust was copied from a marble original by Timothy Butler presented to the Royal Society in London.

On the Falconer's Tolbooth Street front, high above a projecting cornice punctuated by affable stone lions, is a medallion carved with a low-relief profile portrait of Prince Albert. He is not named. There was no need. Queen Victoria's consort was a celebrity too well known to require a caption. And the Falconer Museum is a proper place for the popular prince. Albert died in 1861, a decade before the Falconer opened. But the cult that the grieving queen created around her beloved husband's memory ensured he would not be forgotten. And Albert's legacy lasts to the present day. The Prince Consort's enthusiasm for art, science and industrial technology culminated in his involvement in the Great Exhibition of 1851. This celebration of British Imperialism and creativity, in the Crystal Palace in Hyde Park, generated a profit that underwrote the creation of a museumopolis in South Kensington: beginning with the institution that would become the V & A; and most gloriously epitomised by the gothic cathedral of the Natural History Museum. Victorian academics regarded museums as the dynamic institutions that would both enshrine human knowledge and drive scientific progress. And so Prince Albert was apotheosed (permission was not required) as a presiding genius for the Falconer Museum.

But it is the Falconer heads that most catch the eye and intrigue the casual visitor. The keystone of each round-arched window carries a single portrait head. The Falconer's keystone images are carved in a hard grey sandstone that contrasts with the mellow yellow ashlar of the museum masonry. The execution is stiff and formal; and the eight grey faces of the scientific and cultural worthies stare from the façades with sombrely compelling gravity. The heads were carved by Thomas Goodwillie, sculptor in Elgin. Goodwillie's bread-and-butter work was gravestones: at Birnie he memorialised

farmers with a flourish of wheatsheaf; in Elgin's new cemetery he dignified bourgeois graves with tasteful classicism. Goodwillie's masterworks are the monumental Duke of Gordon on Elgin's Lady Hill and an exuberant confection of lions rampant, foliage and heraldry for the Earl of Seafield's remodelling of Cullen House. Goodwillie was the stone-carver of choice for Elgin architects, enlivening the burgh's newbuilds with playful animals and floridly classical keystone masks. For the new mart at Forres (designed by A. & W. Reid) Goodwillie sculpted a keystone bull, a ram, and an ironically naturalistic wheatsheaf with neep-and-tatty. Goodwillie's Falconer sculptures find echoes among A. & W. Reid's Elgin buildings. Notably, the affable lions who peer from the Falconer cornice have cousins on the Italianate Elgin Club in Commerce Street – where keystone sculptures bear a familial resemblance to the Falconer Museum heads.

 Nobody remembers how and by whom these eight genii were chosen. Most (but not all) of the heads belong to contemporaries and colleagues of Hugh Falconer. All were dead. Unfortunately, there is no secret recording of the table-thumping and high emotion that amplified arguments among the advocates of various candidates. (Edison's phonograph still lay a generation in the future.) Presumably, the provost and councillors of Forres and the parish minister had a loud voice in the discussion; but the Falconers' relatives, including Hugh's niece, Grace Anne Milne, museum subscribers and colleagues among the nationwide network of botanists and geologists probably also made suggestions for the Falconer pantheon. With benefit of hindsight, we might point out several glaring omissions. William Smith 'The Father of English Geology' surely deserved a place. Wallace and Darwin too; but they were disqualified by being still alive. And theories of evolution were commonplace by the 1860s – and the Darwin mythology was still being evolved (by his disciple T. H. Huxley). Burns was perhaps too louche and democratic to join the sturdily

academic (and Free Church) company of museum heads. And Shakespeare was too English. But where are the women? Ada Lovelace (1815–1852) might have been head-hunted for the Falconer keystone team, though she was an English metaphysical mathematician who might sit uneasily among so many Scottish naturalists. So what about the fossil-hunter Mary Anning (1799–1847)? But she too did not belong to the Scottish/Indian/naturalist circle – and certainly was not one of the boys.

The final selection of heads for the museum keystones reflects Hugh Falconer's world and the small-town predisposition of the Forresian middle class. The main door on the High Street front is flanked by Georges Cuvier and Isaac Newton. Cuvier (1769–1832) was an anatomist who applied his comparative method to living species and extinct mammals before progressing to a consideration of racial diversity in humankind. And he was a moderate political liberal who resisted the reactionary *ancien régime* conservatism of the restored Bourbon monarchy in France. Cuvier was admired in his own time; and his reputation was undiminished in the mid-nineteenth century, when he was honoured as the 'Father of Palaeontology'. Newton (1642–1727) balances Cuvier on the museum front, perhaps because he could not be ignored in the roll-call of scientific worthies – even though he was English, long dead, and his main achievements were in mathematics, optics and currency reform. Nonetheless, every Victorian schoolboy could recite a version of Newton's laws and understand the nature of white light as a rainbow spectrum of colour. Famously Newton declared "If I have seen further it is by standing on the shoulders of giants". And Newton was himself a giant upon whom later science rested.

The Falconer heads selection committee may have been assisted by the popular biographical works of Samuel Smiles, whose *Self-help* (1859) was on the bookshelf of every circulating library, Mechanics Institute, and petit-bourgeois parlour.

Smiles created a Victorian mythology of small-town poor-boys who rose to greatness through natural genius, thrift and hard work. Among the museum heads are Hugh Miller (1802–1856) and James Watt (1736–1819). Both were admired (and partly invented) by Smiles, as autodidacts who overcame humble origins to dominate their chosen fields (geology and engineering). Of course, the reality was more nuanced. Both men came from comfortable homes; and neither was obliged to go out to work until late in his teenage years. Watt's father was a Greenock businessman and town councillor; his uncles were mathematicians, land surveyors and engineers. There was no need for a tea-kettle to inspire young James with a passion for steam power – which was in fact encouraged by generous academics at Glasgow University. Hugh Miller's sea-captain father could afford a showy Cromarty townhouse for his family – though in subsequent mythologising this was overshadowed by the humble thatched Hugh Miller cottage next door. And Miller was educated for a professional career. He became 'the stalwart stonemason' in a fit of teenage rebellion; and when that career choice palled his education and family connections secured him a comfortable desk job in the Commercial Bank. James Watt's technical innovations were seminal for later industrial progress; but he made his fortune through partnership with the shrewd Birmingham capitalist Matthew Boulton. Miller's original discoveries and insights were applauded within the geological community. But Miller enhanced his own image through a carefully cultivated eccentricity. Unfortunately, his scientific rationality was spiced with an explosive mixture of Christian zeal and native superstition (which went far beyond ordinary religious observance or academic folklore study). Eventually the heady cocktail of science and superstition frothed to a crisis. Miller went mad and shot himself. It was the sensation of his suicide rather than the solidity of his science that secured his reputation.

Sir Walter Scott (1771–1832) hangs uneasily from his keystone, uncomfortable in the company of so many brilliant scientists. But Goodwillie carved Scott larger than the others and that must mean something. Walter Scott was a prosperous lawyer, a popular poet, and when his creditors came a-knocking – a prolific novelist. Especially, Scott managed to be a literary celebrity without unsavoury scandal in his personal life. And Scott was a conservative unionist and monarchist, uncontaminated by the republicanism of earlier romantics; and he was active in crushing working class radicalism in 1820. In poetry and prose Scott nicely glossed over the uncomfortable improprieties of everyday existence: his novels were enjoyed by Queen Victoria and could be safely read by middleclass maidens. Scott infused his writings with potent historical myths and a romanticism that created an identity for Scotland, helping to restore the national pride that had been shaken by civil conflict, economic collapse, and union with England. Scott reinvented Scotland for the nineteenth century, and so earned himself a place on the Falconer façade.

David Brewster (1781–1868) was a scientific heavy-weight. He was included among the heads probably as a late entry, having qualified for inclusion by dying just as the museum design was being finalised. Brewster's field was optics, applied practically to lighthouse design. He was also (with Hugh Miller) a leader in the tentatively democratic modernising clique that propelled the Disruption of 1843 and the formation of the Free Church. Brewster's science was realised in playful popular applications. Children were delighted by the Brewster kaleidoscope. And Brewster's improved stereoscope brought 3-D images of faraway places into Victorian drawing rooms.

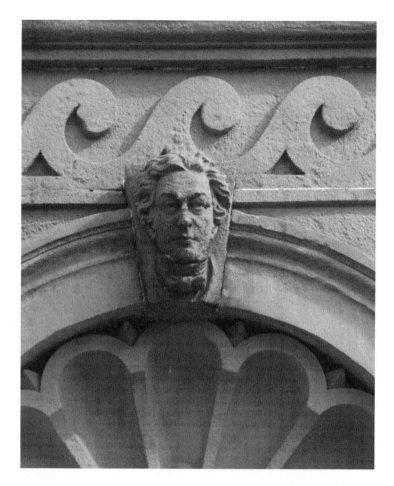

Edward Forbes, founder of the new science of oceanography, keystone portrait by Thomas Goodwillie. Photo © Christine Clerk

Edward Forbes (1815–1854) is misnamed 'Edmund' on his Falconer Museum lintel. Forbes was a naturalist and founder of the new science of oceanography. And he was an affectionate friend of Hugh Falconer. Especially he drew playful cartoons – in the nonsense genre of Lewis Carroll, Edward Lear, and John Tenniel. One of Forbes' drawings depicts Hugh Falconer as an amiable elephant tipsily perched on the back of a tortoise. The cognoscente would recognise

this as a reference to Falconer's discoveries – of fossils of pygmy elephants and a gigantic tortoise – viewed through the lens of Hindu mythology. The Forbes cartoon was realised as an astonishing sculpture: In 2018 Dom Buxton's *Tortiphant* was installed in the museum as the last major addition to the collection before closure.

John Grant Malcolmson (1802–1844) was a local scientist who was a particular friend and counterpart of Hugh Falconer. Malcolmson trained as a physician and, like Falconer, he sought his fortune in India, where he too discovered geology. Malcolmson published original medical research; but especially he studied the geology of Moray, collaborating with an energetic network of local fieldworkers, who explored the stratigraphy and fossils of the coastal sandstones. Malcolmson probably intended to retire to Forres; this must have been planned in conversation with Falconer. But he died in India. And (except for his carved head on the museum) Malcolmson never became an ornament to the royal burgh.

Nineteenth-century Britain was a small world, and intricately connected. The coincidences and chance meetings that propel the plots of nineteenth-century fiction might jar with readers in the alienated, unconnected twenty-first century; but such syzygies would seem unremarkable to contemporary readers. So, in the manner of a sprawling Victorian novel, we can trace threads that enmeshed the Falconer heads men in a single-story web of intersecting networks. In particular, Falconer, Malcolmson and Miller were all Moray men, all born in the first decade of the new century (Malcolmson and Miller were born in the same year – 1802). They grew up within easy reach of Forres – at Keith and, a short hop across the firth from Findhorn, at Cromarty. Malcolmson, like Falconer, sought his fortune in India; and so both were involved in the same broader colonial community. Malcolmson and Forbes were connected by their shared friendship with Falconer. Miller was connected to Brewster as

a fellow pioneer in the early Free Church. Brewster connects to Scott in his *Letters on Natural Magic*, which were addressed to Sir Walter. Meanwhile, geological giants who were not included among the museum heads, including J. L. R. Agassiz (1807–1873) and Roderick Murchison (1792–1871) bound the community of fieldworkers in a Gordian tangle of written communication. The complex ramifications of personal, political, financial and familial relationships among the heads men, and their collaboration with the busy community of Moray scientists and membership of academic societies, are further fertile grounds inviting deep biographical exploration.

The Falconer Museum struck deep roots in the heart of Forres. But the Falconer rested upon shaky financial foundations. More than once the museum trustees ran out of money. However, Forres Town Council accepted the responsibility: valuing its local museum as an educational resource and a cultural ornament. Until the powers and corporate identity of the royal burgh were extinguished in 1975 – subsumed into a new Moray District Council. Still, an old guard of former Forres councillors promoted their museum as a precious jewel among cultural treasures engrossed in the care of the new local authority. The Falconer joined a glorious architectural inheritance that included Nelson Tower, Oldmills, Craigellachie Bridge, Bow Bridge, Grant Lodge, and several stunning town halls – all subsequently burned down or otherwise alienated from public care. Meanwhile, across the road from the Falconer, the Tolbooth – the political heart of old Forres – was promoted through the efforts of the last provost, Alfred Forbes, to an appropriate new role as the Moray District Record Office. MDRO assembled an unrivalled local archive collection. For a short time Forres – tolbooth and museum – thrummed as a pioneering cultural and historical powerhouse that enshrined the history and identity of ancient Moray.

But only fleetingly. The archival eggs, gathered in one basket, were dangerously exposed. A new crop of councillors decimated – and more than decimated – the archives. In 1998 the service was shut down and the surviving rump of Moray's documentary heritage was sent to Elgin. The Tolbooth, now an expensive white elephant, was abandoned as a symbolic *coup de grâce* for the Royal Burgh of Forres.

Meanwhile, in 1996, the Moray Council formally acquired the Falconer, under a promise to manage, administer, finance, and preserve the museum. But promises intended to last in perpetuity are sooner or later regretted. Sooner in the case of the Falconer Museum. Where archives led the Falconer was doomed to follow. Moray Council chafed at the cost of its public museum service. Councillor trustees tired of their responsibility, discovering that the museum was variously, irrelevant to the tourist economy, extraneous to the school curriculum, an unaffordable luxury, an anachronism, or an assemblage of stuffed weasels. Council officials assessed museum collections for possible sale. Several councillors declared they would be heartbroken if the Falconer closed – and then voted for closure.

The Falconer Museum was shut in 2019. In an age of pessimism, atrophied attention spans and penny-pinching pragmatism, the vacuum left by the retreat from public funding and public services was not filled by private money. The management of a professional museum service is beyond the ragged-trousered philanthropy of Friends, enthusiasts and old fogeys – who are already stretched to the limit by the slave-labour of covering a slew of abandoned public services (horticultural, educational, archaeological, social, environmental, historical, cultural).

And so we celebrate 150 years of the Falconer Museum with the doors shut fast. The Falconer Museum – a precious gift from the past to posterity – teeters on the brink of disintegration. The museum's stone heads hold their breath, hoping for a future ...

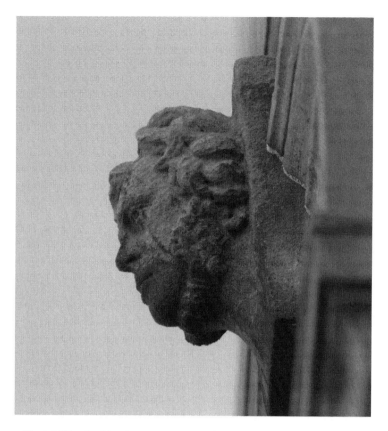

Hugh Miller, looking into an uncertain future of the Falconer Museum, keystone portrait by Thomas Goodwillie. Photo © Christine Clerk

About the author

Dr John R Barrett is a professional archivist and archaeologist. He has published numerous books and articles including historical fiction for young readers and academic studies of the landscape and history of North East Scotland.

Three different species of humans

An exceptional assemblage from an exceptional museum

Dr Torben B Ballin

In 2014, the author spent a week in Moray to investigate the archaeology and geology of the local area. In this context he also visited two local museums – the Falconer Museum in Forres and Elgin Museum – where he classified and catalogued the museums' lithic collections and held a public workshop on lithics at each museum.

Both museums had in their collections interesting lithic artefacts from the local area, many of flint, but also many of local silcrete/Stotfield chert (Ballin & Faithfull 2014). However, the greatest surprise was to discover in the collections of the Falconer Museum an unexpectedly large and important assemblage of Palaeolithic flints covering several hundred thousand years of human prehistory – a collection which, on this point, matches those of the National Museum in Edinburgh, the Hunterian Museum and Kelvingrove Museum in Glasgow. The assemblage includes 10 flints of Lower Palaeolithic age (the Acheulean), four flints of Middle Palaeolithic age (the Mousterian/Levalloisian), and 55 pieces

of Upper Palaeolithic age (the Magdalenian; see catalogue of Palaeolithic finds from the Falconer Museum at the end of this paper).

Interestingly, the three lithic industries are associated with three different species of humans, namely *homo erectus*, *homo neanderthalensis* and *homo sapiens*. The former two species are extinct, whereas we belong to the latter species. The earliest remains of *homo erectus* are approximately 2 million years old, and this species died out *c.* 110.000 years ago. The first Neanderthals occurred several hundred thousand years ago and probably died out *c.* 30,000 years ago. *Homo sapiens* probably developed in Africa several hundred thousand years ago and arrived in Europe *c.* 45,000 years ago. It has been suggested that our species, *homo sapiens*, may have been partly responsible for the extinction of the Neanderthals.

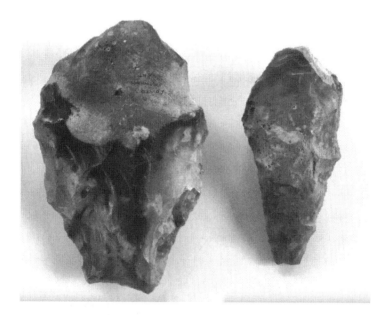

Fig. 1. A large hand axe with a repaired tip and a small ficron hand axe, both from Lower Rainham, Kent, and both probably dating to the Acheulean (from the author's private collection, photo: B. Ballin Smith).

The Acheulean material from the Falconer (from the eponymous St Acheul site in Dordogne) includes several hand axes, the key diagnostic artefact form of this industry (Fig. 1). The Mousterian/Levalloisian material (from the eponymous site Le Moustier, Dordogne) includes an unmodified flake and a side-scraper based on blanks produced in the Levalloisian technique, which resulted in typical faceted platform remnants (Fig. 2). And the most numerous of the three Palaeolithic sub-assemblages from the Falconer, the Magdalenian collection (from the eponymous sites La Madeleine and Les Eyzies, both Dordogne), includes flints potentially of relevance to the continued search for Hamburgian material in Scotland.

Fig. 2. The operational schema of the Late Acheulean/Mousterian Levalloisian (Roe 1981, Fig. 3:9): I. Basic shaping of nodule, II. preparation of domed dorsal surface, III. preparation of faceted striking platform on core, IV. the flake and the struck core, with their characteristic features (drawn by the late M.H.R. Cook).

The Hamburgian is a spin-off of the Magdalenian industry, and the three industries the Magdalenian, the Creswellian (another Magdalenian spin-off) and the Hamburgian shared the same lithic technology. It is thought that the Hamburgians arrived in Scotland after having crossed Doggerland, the then dry bed of the North Sea, from their original homeland in northern Germany or southern Denmark (Ballin 2016).

The Magdalenian is mostly associated with France but is also represented in various Central European countries

and in Spain. The Creswellian is mostly associated with southern England and Wales but is also represented in the Low Countries (so far not in Scotland). And the Hamburgian is mainly associated with northern Germany and southern Denmark; but is also represented in the Low Countries, Poland, and Scotland. This paper focuses on the relevance of the Falconer's Magdalenian finds to the continued research into the earliest prehistory of Scotland.

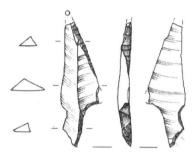

Fig. 3. Typical Havelte point from Howburn, South Lanarkshire (Ballin et al. 2018; artist: M. O'Neil).

The earliest known lithic finds from Scotland are those from the Late Hamburgian site of Howburn in South Lanarkshire, with a date of *c.* 14,000 BC (Ballin et al. 2018). It has been suggested that two flints from sites on the Dee in Aberdeenshire (Clarke in Wickham-Jones et al. 2021, Figs. 7.14 and 7.47) are Early Hamburgian shouldered points, but it is this author's view that 1) neither fits the definition of a shouldered point (one having the general outline of a shouldered point but not the necessary basal modification, and the other is probably an Early Mesolithic isosceles triangle), and 2) the evidence from Continental European sites suggests that the northwards expansion of the Hamburgian (into first Denmark and then Scotland) began around the

Early/Late Hamburgian transition. The finds from Howburn are associated with so-called Havelte points (Fig. 3), that is, asymmetrical tanged points used for hunting, among other things, reindeer.

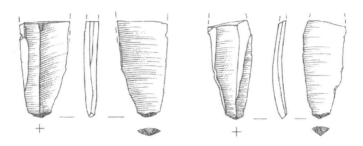

Fig. 4. En eperon blades from Howburn, South Lanarkshire (Ballin et al. 2018; artist: M. O'Neil).

The relevance of the Magdalenian finds from the Falconer to the understanding of the Scottish Hamburgian mainly relates to the technology (the reduction technique or operational schema) of the two industries, as their tool kits shared some elements but also varied on a number of points. First and foremost, the tool blanks of both industries were produced by the application of the so-called *en eperon* technique, leaving similar tool blanks (flakes and blades) and similar cores. As shown in the appendix listing of the Palaeolithic finds from the Falconer, the museum's Magdalenian finds include several *en eperon* blades. An *en eperon* blade is a blade which has a finely faceted platform remnant with a small spur at the front (in French, *eperon* means 'spur'; Fig. 4). The collection also includes at least one typical opposed-platform core (Fig. 5). The purpose of detaching blades from two opposed ends of a core was to produce straight blades which could be transformed into straight arrowheads.

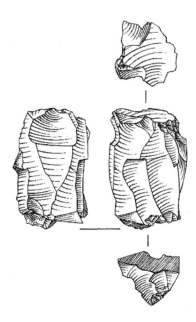

Fig. 5. Opposed-platform core from Howburn, South Lanarkshire (Ballin et al. 2018; artist: H. Martingell).

The Magdalenian assemblage from the Falconer also includes several typical blade tools, such as one truncated flake and six blade-scrapers.

In the bigger picture, the Palaeolithic finds from the Falconer Museum have several use values, such as supporting the continued research into the Scottish Hamburgian by offering insight into the Period's main lithic reduction technique (shared with the Magdalenian and Creswellian industries), but also by giving young Scots an opportunity to look into the daily lives of the Acheuleans and the Neanderthals, two now extinct species of human beings. With the artefacts from three lithic industries, visitors of the Falconer Museum can look at three different species of humans at once, *homo erectus, homo neanderthalensis* and *homo sapiens*.

In terms of its research potential, the early Palaeolithic material from the Falconer clearly matches similar collections at the larger museums in Edinburgh and Glasgow.

Literature

>Ballin, T.B. 2016: Rising waters and processes of diversification and unification in material culture: the flooding of Doggerland and its effect on north-west European prehistoric populations between ca. 13 000 and 1500 cal BC. *Journal of Quaternary Science* 32(2), 329-339.

>Ballin, T.B., and Faithfull, J. 2014: Stotfield 'cherty rock'/silcrete – a 'new' lithic raw material from Scotland. *CIfA Finds Group Newsletter* Autumn 2014, 3-8.

>Ballin, T.B., Saville, A., Tipping, R., Ward, T., Housley, R., Verrill, L., Bradley, M., Wilson, C., Lincoln, P., and MacLeod, A. 2018: *Reindeer hunters at Howburn Farm, South Lanarkshire. A Late Hamburgian settlement in southern Scotland – its lithic artefacts and natural environment.* Oxford: Archaeopress.

>Roe, D.E. 1981: *The Lower and Middle Palaeolithic Periods in Britain.* London, Boston, and Henley: Routledge & Kegan Paul.

>Wickham-Jones, C., Bates, R., Cameron, A., Clarke, A., Collinson, D., Duthie, S., Kinnaird, T., Noble, G., Ross, I., Sabnis, H., and Tipping, R. 2021: Prehistoric communities of the River Dee: Mesolithic and other lithic scatter sites of central Deeside, Aberdeenshire. *Scottish Archaeological Internet Reports* 97.

APPENDIX – Palaeolithic finds from the Falconer Museum

Museum reference			Description	Site
Lower Palaeolithic				
1897	25	B	Cordate hand axe	St Acheul, Valley of the Somme
1897	25	C	Cordate hand axe	St Acheul, Valley of the Somme
1897	25	D	Irregular hand axe	St Acheul, Valley of the Somme
1897	25	e	Cordate hand axe	St Acheul, Valley of the Somme
1897	25	f	Cordate hand axe	St Acheul, Valley of the Somme
1897	25	g	Small cordate hand axe	St Acheul, Valley of the Somme
1897	25	h	Hard-hammer blade	St Acheul, Valley of the Somme
1981	81	ao	Hard-hammer flake	St Acheul, Valley of the Somme
1981	81	ap	Ficron hand axe	St Acheul, Valley of the Somme
Middle Palaeolithic				
1979	194	b	Hard-hammer flake	Le Moustier, Dordogne
1981	81	ad	Levallois flake	Le Moustier, Dordogne
1981	81	ae	Side-scraper on Levallois flake	Le Moustier, Dordogne
1981	81	af	Side-scraper on distal flake frag.	Le Moustier, Dordogne
Upper Palaeolithic				
1979	194	c	Distal frag. of blade	La Madeleine, Dordogne
1979	194	d	Distal frag. of blade	La Madeleine, Dordogne
1979	194	e	En eperon blade w retouch	La Madeleine, Dordogne
1979	194	f	En eperon blade	La Madeleine, Dordogne
1979	194	g	Distal frag. of blade	La Madeleine, Dordogne
1979	194	h	Blade	La Madeleine, Dordogne
1979	194	i	Distal frag. of blade	La Madeleine, Dordogne
1979	194	j	Blade	La Madeleine, Dordogne
1979	194	k	Blade	La Madeleine, Dordogne
1979	194	l	Blade	La Madeleine, Dordogne
1979	194	m	En eperon blade w retouch	La Madeleine, Dordogne
1979	194	n	En eperon blade	La Madeleine, Dordogne
1979	194	o	Blade frag.	La Madeleine, Dordogne

THREE DIFFERENT SPECIES OF HUMANS 29

1979	194	p	Distal frag. of blade	La Madeleine, Dordogne
1979	194	q	Distal frag. of blade	La Madeleine, Dordogne
1979	194	r	Distal frag. of microblade	La Madeleine, Dordogne
1979	194	s	Blade frag.	Les Eyzies, Dordogne
1979	194	u	Soft-hammer blade	Les Eyzies, Dordogne
1979	194	v	Truncated flake	Les Eyzies, Dordogne
1981	81	a	Blade frag. w retouch	La Madeleine, Dordogne
1981	81	b	Blade frag.	La Madeleine, Dordogne
1981	81	c	Blade frag.	La Madeleine, Dordogne
1981	81	d	Distal frag. of blade	La Madeleine, Dordogne
1981	81	e	Flake	La Madeleine, Dordogne
1981	81	f	Blade	La Madeleine, Dordogne
1981	81	g	Microblade	La Madeleine, Dordogne
1981	81	h	Distal frag. of blade	La Madeleine, Dordogne
1981	81	i	Blade	La Madeleine, Dordogne
1981	81	j	Distal frag. of crested blade	La Madeleine, Dordogne
1981	81	k	En eperon blade	La Madeleine, Dordogne
1981	81	l	Blade frag.	La Madeleine, Dordogne
1981	81	m	Distal frag. of blade	La Madeleine, Dordogne
1981	81	n	Frag. of microblade	La Madeleine, Dordogne
1981	81	o	En eperon blade	La Madeleine, Dordogne
1981	81	p	Distal frag. of blade	La Madeleine, Dordogne
1981	81	q	Flake	La Madeleine, Dordogne
1981	81	r	Crested blade	La Madeleine, Dordogne
1981	81	s	Blade frag.	La Madeleine, Dordogne
1981	81	t	Blade	La Madeleine, Dordogne
1981	81	u	Crested microblade	La Madeleine, Dordogne
1981	81	v	Blade-scraper	La Madeleine, Dordogne
1981	81	w	Blade-scraper	La Madeleine, Dordogne
1981	81	x	Blade-scraper	La Madeleine, Dordogne
1981	81	y	Blade-scraper	La Madeleine, Dordogne
1981	81	z	Blade-scraper	La Madeleine, Dordogne
1981	81	aa	Blade-scraper	La Madeleine, Dordogne
1981	81	ab	Poss. opp.-platf. core or robust burin w burin-edges at three corners	La Madeleine, Dordogne
1981	81	ac	Opposed-platform core	La Madeleine, Dordogne
1981	81	ag	Blade scraper	Les Eyzies, Dordogne
1981	81	ah	Distal frag. of blade	Les Eyzies, Dordogne

1981	81	ai	Frag. of side-scraper	Les Eyzies, Dordogne
1981	81	aj	Distal frag. of blade	Les Eyzies, Dordogne
1981	81	ak	Blade w finely faceted platform remnant	Les Eyzies, Dordogne
1981	81	al	Blade w finely faceted platform remnant	Les Eyzies, Dordogne
1981	81	am	Blade w finely faceted platform remnant	Les Eyzies, Dordogne
1981	81	an	Single-platform blade-core	Les Eyzies, Dordogne

About the author

Torben Bjarke Ballin, PhD 1999 University of Aarhus. Director and Consultant Archaeologist at Lithic Research, Stirlingshire, carrying out basic and sophisticated analyses of lithic assemblages and their prehistoric contexts. E-mail: lithicresearch@gmail.com Website: https://independent.academia.edu/TorbenBjarkeBallin?from_navbar=true

The thing and the thing itself

Teachings of the Falconer flints

Ruth Fishkin

The side of the box said 'St Acheul'. No way, I thought. The type-site, the place where the humans of Europe found their origin?

St Acheul. The French archaeological site, discovered in the 19th century, the name-place of the earliest human culture in Europe - human culture from a time so long before history that 'human' was not as we know it. St Acheul is where western science first perceived that prehistory goes back millions of years, not just thousands, and that our ancestors in deep time were different species.

Type-sites are unique, the objects collected from them precious lodestones for human understanding of how we got to be who we are. That's why I knew the name, and there it was. In big scribbled black letters, fuzzy marker pen, decades old and dusty. In the collection store-room of a small museum in a small town in a sweet Scottish backwater of the far fringe of the continent, across a channel from France. St Acheul? Surely not.

It was weeks before I dared look into the box.

I was a new volunteer, you see. It was a strange privilege just to be there, unsupervised, one rookie volunteer alone up in the museum storage. Just me in the unwindowed dark with the entire collection, ghosts and swords and spinning wheels in fifteen rolling stacks.

They'd pretty much showed me in and let me give myself the tour. There was no choice; the museum service budget and staff had been cut, again, and the remaining employee available that day had half a dozen volunteers, combined age somewhere over 400, and two and a half hours to get as much done as those six pairs of hands could manage in one narrow morning. She had a long and growing list. Several hundred thousand things needing curation, cleaning, cataloguing, care and sorting out. Prep for the summer's worth of workshops in the museum for the local school kids, plus the teenagers who would be coming to do their Duke of Edinburgh Award projects. The giant map of the shops in the old High Street, that needed to go to local care home residents for their memories, before its open days in the library... and then she couldn't stay away from her computer for too long, since it would be full of events in the process of being organised, and requests for access to various bits of the collection from palaeontologists and historians and students of butterflies, archaeologists, botanists, storytellers, and people searching for their ancestors. All of these needed a professional answer, so the only professional left talked with me a bit, judged that I was reasonably safe and reliable, and left me to it. I guess she was right. Because it was weeks before I let myself look in that box.

When I did, I knew what I was seeing: The thing, and the thing itself. Eight Acheulean hand-axes, flint from the type-site, a quarter million years old. Made by the hands of my ancestors several species back, collected by the first Europeans to dimly understand their own history in deep time. The very

stones that troubled the thoughts of Darwin, Falconer, and Curie. Still carrying the mud of St Acheul and the Victorian ink of Franks and Falconer.

The thing, and the thing itself.

The boxes next to that one in Bay 6, the archaeology stack, were marked with other names I knew, other type-sites of Europe's deepest history: Les Eyzies; Le Moustier, the name-place of Neanderthal culture; La Madeleine, type-site of earliest modern human culture, from the end of the last Ice Age. These boxes also contained the real things.

Many happy years spent with the museum followed those lightning moments, remembered as a breath held while I lifted the lid, and the bright white flash of realness underneath. In following years, I spent less time with these august boxes than with the local archaeology collection. There were thousands of flints – and ceramics, and bones, and the mud-and-straw plaster from between the lath of vanished houses, and the bowl-shaped rough slag core left at the bottom of a two-thousand-year-old smithing hearth, and the querns that ground the flour for the bread that raised grandmothers' grandmothers half a hundred grandmothers ago - all from right here. Millenia newer and from my own species, and my own home. Mesolithic and Neolithic and Bronze Age, the history of where I live, the thing itself of my own town, before there was a town, before the Roman invasion was a glint on a distant spear-point.

The French lower palaeolithic material was sacred. Those flints still showed the mud of the type-sites here and there, not yet rubbed off by the crazily short chain of hands that brings them a quarter million years from making to now. The maker, the wielder, the finder, Falconer, the curator, the lithics expert, me. I touched them, but not often.

But every day I came to the museum lab I opened the many boxes of local flints. I learned them.

Recently, missing the closed Falconer, I visited a small local heritage centre. Actual paid staff was a pipe dream there; the whole thing had been running on nothing but volunteer labour and good will for years. It was open.

The flints were glued to a board with epoxy, and some of them were missing, just a spot of old, dried glue left. 'Kids nick them,' said the volunteer on duty.

I guess kids appreciate the real thing.

I took a tour of a local heritage site. I had to pay for the tour; the only way they could pay for the heating, I suppose. All the guides were volunteers, and about half of their narrative was actually historically true. Maybe nobody minded; maybe the other visitors were only looking for half an hour's amusement, with a nice story. Not the thing itself. If anybody had been there looking for the real thing, they would have been let down.

Back when the Falconer Museum was open, I had the real thing, right there in those archival cardboard boxes. I learned lithics from those real things.

I helped catalogue them. I learned to write the numbers that uniquely identify each accessioned object on each flint, with black pigment ink and a nib pen, and to cover the ink with the particular paraloid B72 lacquer which protects the number but can be completely removed without changing the object. I researched how to do it. The Smithsonian in the United States had a very useful website, giving practical advice. I learned that an old bottle for clear nail varnish carefully cleaned out is ideal, with its tiny brush, for applying paraloid B72 lacquer... All that is one kind of learning.

Also I learned how to recognise a plano-convex knife, and to be able to suspect which of the hundreds of flints earlier catalogued as 'scrapers' might be something else, and to recognise the particular low-quality but usable stone that outcrops at Lossiemouth, just in that one place nearby, and see when a very local but very grubby source material had been

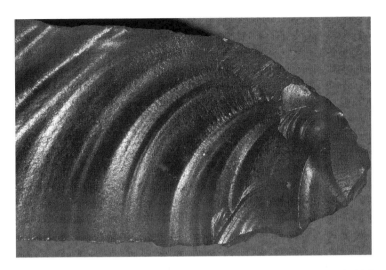

A piece of worked flint (perhaps Neolithic) clearly showing conchoidal fracture. This is the way high-quality flint fractures when struck. The shell-like ripples are not made but occur naturally on impact; they record the dispersion through the material of the force of the blow that broke it. This shape is a frozen instant of the past. It records that moment, perhaps six thousand years ago, when an ancestor's hand lined up a chosen implement and struck a chosen stone. Photo © Michael Sharpe

used to make something. I learned to see as entirely different the very fine grey flint that got imported all the way from Yorkshire at a particular time in the Neolithic... And this was another kind of understanding, something that lives between hand and eye and brain, not solely in any of them.

Nor is the fellowship that such understanding brings when shared a thing that lives in any one place. I read articles and hung out with the archaeologists who used the lab for post-excavation work. They taught me taphonomy and how to wear out a toothbrush scrubbing 2000-year-old iron slag samples, and stratigraphy and site-drawing and the deliciousness of the museum staff's email accounts getting frozen by the Council's no-bad-language algorithms, when they had been sending messages about the site with all the slag. ('Slag' is the

correct and only term for metalworking residue. In British English it is also a very derogatory and rude slang term for a woman, suggesting overly loose moral values.) We shared strong tea and cake recipes and undertook, together, the complex surgery and chemical treatment required to rescue a 4000-year-old axe with bronze disease. I learned how to handle colour-change indicator silica gel.

A dedicated expert on flint technology visited for a day and I got the lithics collection lined up on the lab tables, so he could see as much as possible of it in that brief visit. Then I spent the next year with his notes, improving the information in the museum catalogue and my own brain, taking each flint, looking to see what he saw, and writing his identification on the object's card. The museum catalogue is on 6x8 inch stiff paper cards, in metal drawers. There are about 30,000 cards in the main file, each often recording many related objects. There was one particularly plump accession number, created in 1979 during a big burst of cataloguing activity, one card that covered 514 flints. I looked at them all, one by one, and gave each a unique number to identify it, with an educated guess what it was.

Yes. Hundreds of tiny objects, little old stones, long files, paper files for goodness' sake, nib pens and a tiny bottle of lacquer... It's not the tomb of the Pharaohs! And it doesn't have a QR code.

Yes. It's exacting, and detailed, and kind of old-fashioned – and real.

These things are real. They are things made by the grandfathers of our grandfathers fifty grandfathers ago. For the French stuff, a thousand grandfathers ago. They are real. What else is there that can be held in the palm of the hand and has roots this deep in us?

Every time, every time I took one of those flints in my hand, I was aware of the tiny charge, like electricity, like a fraction of the lightning bolt that grounded itself in me the

first time I opened the St Acheul box. The real thing carries a charge. The energy is recognition, is understanding: *this* is the thing, the thing itself.

Understanding teaches itself, understanding recognises itself, making sense of the world.

One day I opened a dusty drawer in another part of the museum storage; the label said it was full of Pleistocene fossils from India. It was. But in the middle of camel ankle bones and antelope antlers and giant tortoise bits sat – a ninth Acheulean hand-axe.

Another bolt earthed itself through my soles.

It was the missing one from the catalogue. Left there years or decades ago, because it was a stone and the fossils were stones, or because someone had a sleepless night and then put down their coffee somewhere... but it wasn't lost. It got found eventually. Because you can tell the real thing, when you learn to look.

The only thing that can teach you to look and see the real thing, is the real thing. The thing, and the thing itself.

What a museum is for.

Yes, to the kids making felt, or writing with goose quills for an hour. Yes, to the events with the orchestra and the Tesla coil and the coloured cornflour and the singing and the levitating doll and the people coming from the other side of the planet to reclaim their ancestors' bones. Yes, to the singing.

Yes, to the ray of light that the map of old remembered shops on the high street brings to the folk at the care home. Yes, to the glowing hearth of friendship shared by the volunteers having tea, their hands stained with dust and ink and silver polish.

Yes, to the child staring into the case, at the real thing.

The thing, and the thing itself.

About the author

Ruth Fishkin has lived in Forres since 1999 and been a museum volunteer since 2011. She is a past vice chair and current committee member of the Friends of the Falconer Museum. Her work (past, present, paid, unpaid, and for love) includes archaeology, counselling and psychotherapy, writing, museum curation and conservation, jewellery-mending and general survival on the fringe of the socio-economic bell curve.

'What to bin and what to keep'

Museums as collective memory

Scott Keir

The objects seem so old. And I remember being young. Did I think I was young when I looked in the case? How often are we actively aware of our age as we view the world? Many of my friends from my twenties are still my friends, and looking at them, it does not feel that I nor they have aged; we are as we were, friends, old friends. Only photographs, diaries, records, speak to the passage of time. Compared to those photos I am greyer, dustier, less energetic than my sense of self now would like to believe.

So it is with those memories of the objects in the case in the Falconer Museum when I was young. I remember that I was young when I saw them. I know I have changed since I saw them, and my memory has changed too. What did I think of them then? My memories say that I found the museum to be a comforting, interesting place. Is that true, or was I bored? I visited several times for school trips and voluntarily. I drew a picture of the museum on a primary school project book. Perhaps, my brain suggests, I found one of the cabinets – with old items from shops – boring on that trip. Perhaps

I appreciated the steady peace of the museum more as a teenager than when I was younger. I am drawn to museums and galleries now, and when I relocated to Edinburgh as an eighteen-year-old undergraduate, I would seek out galleries and museums for some quiet space in a busy city. Perhaps I had done that in Forres too, as a seventeen-year-old, before I left, almost for good? I forget.

I now know that our memory has a team of archivists, constantly evaluating and sorting what comes in through our senses, and what is already stored in our memories, choosing what to 'thin' – the archivists' term for stripping down dense piles of papers to just the essentials, choosing what to bin and what to keep. Do I really need to remember the precise toppings of my porridge this morning (sultanas) compared with yesterday's (blueberries)? I had breakfast, that will do. As for last week, do I need to remember breakfast at all?

Our memory is autobiographical – we are constantly writing and rewriting the story of ourselves, for ourselves. This is the main thing I remember from a talk I attended over a decade ago, by Douwe Draaisma, author of *Why Life Speeds Up As You Get Older*.[1] We tend to remember novel experiences, and as more new things happen when we are younger, we remember less as we age. Unless we do new things – perhaps in retirement, or just because. But even then, those memories will be edited, sorted, revised, and refiled. I can vividly remember much of the parachute jump I made when I was eighteen – or was I nineteen? – and the part of the car journey home when we almost had an accident, but little of the weeks either side, or even the journey to the airfield. Similarly vivid are some parts of a trip back to Forres including a visit to the Falconer Museum in 2013 where I stumbled into a talk by the

1 Draaisma, Douwe 2004: *Why Life Speeds Up As You Get Older: How Memory Shapes Our Past*, trans. by Arthur Pomerans and Erica Pomerans. Cambridge, UK; New York: Cambridge University Press.

House of Automata – but not all of it has stuck.

Rather than an archive, perhaps our memory is a *Rag and Bone Shop*, the title of psychiatrist Veronica O'Keane's book.[2] A constantly rearranged display of stock around some fixtures and fittings. Each time we visit is a different experience. We see the shop and its contents in a slightly different way. It is not always reliable – is this genuinely solid silver, not silver plate? In a review of Veronica O'Keane's book, Douwe Draaisma approves of this conception.[3] Perhaps my notion of memory-archivists did not come from his lecture after all.

And like a rag-and-bone shop, some memories that we think of as dusty and worthless, we may reappraise, as if we had taken them on *Antiques Roadshow* to be told they were worth a fortune. "Well, I'd never sell it", you say, smiling for the cameras, "it stays with the family". I now recall that museum cabinet of old shop stock, the tins and packets of the high street gone by, with a smile.

I think a lot about memory now. Not only as I am middle aged – 46 at the time of writing – but also as I am back at university as a PhD student researching the history of museums and science centres from the 1980s onwards. This period is within living memory for many, including myself, and one of my research methods is oral history – capturing people's memories and reminiscences as spoken interviews. Historians must consider memory when interpreting and handling these testimonies. Guides and handbooks for oral historians discuss the role of the brain and memory within a person, how our memories may be prompted by a question, a word, a smell, a sound, an object, or another memory, and how our memories are shaped by where we are when we are remembering. I might be more polite or remember something

2 O'Keane, Veronica 2022: *Rag and Bone Shop: How We Make Memories and Memories Make Us*. London: Penguin Books.
3 Draaisma, Douwe 2022: Seahorses in the blob: What gives us our sense of time. *Times Literary Supplement*, 6 May 2022, 20.

different about someone at a funeral than at a wedding, for example. What we don't remember is also something to consider.[4]

What role do museums play in memory? David Lowenthal, the historian who wrote extensively on heritage, describes how history "extends and enriches, confirms and corrects memory through records and relics" in what is probably his best-known work, *The Past Is Another Country*.[5] In another paper, he sums up the role of museums as being explicitly about memory: "Museums exemplify the urge to remember. It is their *raison d'être*".[6] The memory here is both individual and collective, the visitors and the community.

What makes a museum a museum? One of the common definitions of museums is a place where historical objects are preserved and displayed. Unlike a science centre such as Aberdeen Science Centre or Dynamic Earth in Edinburgh where the focus is on objects that are not historical but instead encapsulate concepts. With a PhD on museums and science centres, the devil – and the fun – is in the details, and especially in those cases where those distinctions get blurred.

What counts as historical, for example? You may have experienced the surprise at seeing something from your lifetime in a museum. During a visit to the Falconer Museum in 2013, it was salutary to see computers I had used, now being displayed in a glass case, presented as something from another era, something historic. Because those were. The computer in my pocket was then, and is even more so now,

4 Drawing on Thompson, Paul, and Bornat, Joanna 2017: *The Voice of the Past: Oral History*, Oxford Oral History Series, 4th edition. New York, NY: Oxford University Press.
5 Lowenthal, David 2015: *The Past Is a Foreign Country – Revisited*. Cambridge: Cambridge University Press, 334; https://doi.org/10.1017/CBO9781139024884.
6 Lowenthal, David 1993: Memory and oblivion, *Museum Management and Curatorship*, 12.2 (1993), 171–82, 171; https://doi.org/10.1080/09647779309515355.

leaps ahead of what was in that glass case. Even very recent material could be historical. For a museum today, one of this year's Covid-19 swab tests, or a Queen Elizabeth II memorial poster, could be just as much a relevant object to its collection as a Bronze Age sword, or a Jurassic fossil.

Museum stores are not all filling up with every Covid-19 swab test ever produced however, nor with every crisp packet found on the High Street, because the role of the museum – and specifically the museum curator – is to be selective. Like human memory, the museum memory selects, edits, sorts, revises, and refiles. Memory objects arrive in smaller numbers than human memories arrive in the brain, but museums still assess, filter, store, or dispose. (There is a dedicated classified ads column in the Museums Association's *Journal* for paintings, objects, plane cockpits, and the like, though UK museum standards usually require that objects no longer considered necessary for a collection are given away to another museum and not sold.) Objects can also leave a museum if the purpose, and the memories, are greater elsewhere. The return of ancestral Māori human remains to the Museum of New Zealand Te Papa Tongarewa by the Falconer Museum in 2016 is a beautifully clear example of this. Whatever memories and histories that object provided to the community around Moray pales into insignificance compared with those of the communities of its descendants.

Museums have a role then in being our external memory, for us as individuals, and collectively as a community, as a society. Historian Susan Crane argues that museums are a way we can delegate remembering to something outside our head, with the museum selecting "some memories to retain in the perpetual present".[7] But, as with the memories inside our

7 Crane, Susan A. 2006: The Conundrum of Ephemerality: Time, Memory, and Museums, in Macdonald, Sharon, ed., *A Companion to Museum Studies*. Malden, MA, and Oxford: Blackwell Pub., 102.

heads, each time we visit the museum, even if we have been there before, the experience is different. We are different and we experience this preserved memory stored and displayed in the museum differently.

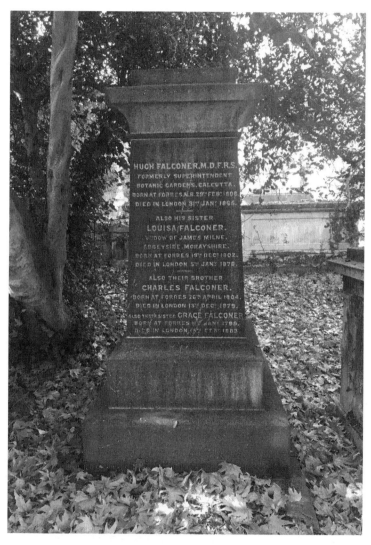

Hugh Falconer's grave in Kensal Green Cemetery, London. Photo © Scott Keir

Who gets to remember, and who gets to choose? Yesterday, I visited Hugh Falconer's grave. He is buried in Kensal Green Cemetery, the first of the 'Magnificent Seven' Victorian graveyards built around London to address – and profit from – the rising population. The Friends of Kensal Green Cemetery claim it as 'Britain's most prestigious cemetery'.[8] Hugh is buried in illustrious company, alongside familiar names including Brunel, Birkbeck, W. H. Smith, Twinings, and more – over 1500 names are listed on the Friends' list of notables.[9] The cemetery is still operational.

Hugh Falconer's grave marker is a tall pedestal on the Central Avenue, in the innermost circle, tucked under some tree branches. Hugh gets top billing, then his sister, "Louisa Falconer, widow of James Milne", their brother Charles Falconer, and their sister Grace Falconer. The gravestone acts as a memory store of some of the Falconer family's existence. As the historian Sheldon Goodman puts it, "Cemeteries are museums of people ... spaces of memory".[10] The cemetery company and the Friends of Kensal Green Cemetery work to maintain these memories for years to come.

But what of Alexander Falconer, Hugh's brother, whose bequest founded the Falconer Museum? His name is not on that pedestal. Little seems to be known about him, or his work. There are traces, including a portrait by an artist. Which artist? That too is unknown.[11] His name and identity lost to our current understanding, our present memory.

Much of what we know and remember about Hugh Falconer is thanks to his friend Charles Murchison, who

8 'Britain's most prestigious cemetery', *The Telamon*, 2020, 3.
9 https://www.kensalgreen.co.uk/notables.php, accessed 15 September 2022.
10 https://twitter.com/CemeteryClub, accessed 15 September 2022.
11 The restoration of Alexander Falconer's portrait – The Falconer Museum, http://falconermuseum.co.uk/the-restoration-of-alexander-falconer/, accessed 15 September 2022.

after Hugh's death published in two volumes a biography together with Hugh's unpublished material.[12] Though the books remain, the original papers are missing. Palaeontologist Victoria Herridge has looked hard for them and hopes they are still out there.[13] The whereabouts of the originals are forgotten, but a record is remembered.

Sometimes these acts of forgetting are due to chance and accident, and sometimes to our own behaviours – burning letters or deleting text messages from ex-lovers, for example. Sometimes the forgetting, or the remembering, is the result of the acts and behaviours of others. Hugh's historical memory has been aided by Charles Murchison and all who supported, bought, and preserved the two volumes, and by all who planned, built, championed, and maintained the museum. These actions usually require elements of power: time, money, prestige, access. Luck helps too. For evidence of this, think of a cemetery that is not maintained, perhaps one that was for poor people, or that has no community of friends. Or think what Hugh's legacy would be like if all that remained was a single letter containing the assessment of his contemporary, Joseph Dalton Hooker, that Hugh Falconer did "mischief" and his name was a "scandal"?[14]

That letter, a private correspondence between J D Hooker and Charles Darwin, discussing how much money to donate

12 Murchison, Charles 1868: *Palaeontological Memoirs and Notes of Hugh Falconer, with a Biographical Sketch of the Author*, compiled and edited by Charles Murchison. 2 vols. London: Robert Hardwicke.
13 Victoria 'Tori' Herridge, Hunting for Hugh Falconer's notebooks in Forres..., reprinted in this anthology. See also: https://toriherridge.com/2012/08/02/hunting-for-hugh-falconers-notebooks-in-forres/, accessed 18 August 2022; Tori Herridge, "His lost notes and diaries plague me. If anyone finds them, please let me know!", https://twitter.com/ToriHerridge/status/1560190531350810624, accessed 15 September 2022.
14 Darwin Correspondence Project, "Letter no. 4773", accessed 15 September 2022, https://www.darwinproject.ac.uk/letter/?docId=letters/DCP-LETT-4773.xml

to Hugh Falconer's memorial appeal, was not made public at the time, of course. It emerged later, from its careful archival store, into academic and then general view. Though some aspects of history may be lost or may fade in our collective memories, other aspects can and do emerge.

It is now more widely known what the East India Company did before and during the time that Alexander Falconer was a merchant in Calcutta, and Hugh Falconer was in charge (despite whatever Joseph Hooker thought) of the botanical gardens. Our understanding of the history of Indian tea has improved, and the effects of the colonial empire are more deeply understood.

This does not mean we should forget all about the Falconers, erase the memory. Rather, our understanding is enriched by this new knowledge, and the stories we tell will adapt. Hooker's letter casts insight into the scientific fights going on at the time in Falconer's circle. Our greater awareness of the East India Company helps us assess those times more honestly.

It is easy to think that we should not judge the past, but to that I offer two responses. We must judge the past; comparisons between then and now are helpful, allowing us to reflect on what has changed, what should change, what should stay the same. And secondly, the past judged the past. People and societies are not monotone and dominant histories, and memories of the past do not represent the whole picture. The effects of the East India Company were known about and condemned at the time by some. The first meeting of the British India Society in 1839 saw speakers condemn the Company for its neglect and oppression.[15]

15 Mehrotra, S.R. 1967: The British India Society and its Bengal branch, 1839-46, *The Indian Economic & Social History Review*, 4.2 (1967), 131–54; https://doi.org/10.1177/001946466700400203.

This shift in memory and understanding can happen at a personal level too. I was absolutely convinced that I attended two memorable events in the same year; I told people I had, I would have sworn that on oath. I was wrong. When I looked in my diaries earlier this month, these two events were a year apart. My memory, that shuffling archive, that rag-and-bone shop, had summarised not quite as it should. With that new knowledge, from those diaries, I now remember differently. Better.

Institutionally, that shift in memory and understanding is happening across the museum sector. I live near to another museum with a link to tea, the Horniman Museum, founded by the tea trader Frederick Horniman. Nick Merriman, the museum's director, committed in 2020 to "tell his story – and that of the collections – in as full and fair a way as we can", which includes talking about how Horniman tea was made and by whom, and how the objects in the museum came to be there.[16] Nick Merriman does not want to remove the Horniman family from the stories the museum tells, but instead, to look again at what is said.

Time has that effect, of changing the lens through which we look at the past, like an optician with their testing kit. And what about now, better, or worse? A, or B? I thought of this as I left my optician one sunny Wednesday lunchtime, after she valiantly tried to balance my distance vision with my reading vision for my prescription. As with history, we need to balance the big picture with the local, the headlines writ large with the fine print in the margins.

The big picture for Forres is that Hugh Falconer was a significant figure in Victorian science, and the Falconer family – including Louisa, Charles, Grace, and the mysterious

16 Merriman, Nick 2020: Frederick Horniman's colonial legacy, *Horniman Museum and Gardens*; https://www.horniman.ac.uk/story/frederick-hornimans-colonial-legacy/, accessed 15 September 2022.

Alexander – contributed to the life and fortunes of Forres and beyond. Within that, we should talk about the society in which they lived, the employers they had, the power and access they were given, the effect they had on the world, and more.

Hugh Falconer, his life and work, and the society he lived in, should be remembered alongside those of other Forresians. These stories should be told. Our personal memories are the stories that we tell ourselves. Our collective memories are the stories that we want to tell others, our communities, our descendants. We do this through words, sounds, pictures, and, crucially, objects. Museums and their stores are important because they contain the memories that we have decided to keep, collectively. And when we see these objects, they help us to tell the stories linked with each memory, and most importantly with our communities. They should not be forgotten, nor should the Falconer Museum.

About the author

Scott Keir is a PhD student in the department of Science and Technology Studies at University College London, funded by a Royal Institution Philip Freer Studentship, researching the modern history of science communication in museums and science centres. He previously worked for the International Centre for Mathematical Sciences in Edinburgh and at the Royal Society and the Royal Statistical Society in London in science communication and education policy roles. He grew up in Forres and has been a member of the Friends of the Falconer Museum for several years. www.scottkeir.com

What are museums for?

Thoughts on museums – and one in particular!

Norman Thomson

What are museums for?

This may seem a rather trivial question, but it is one which, in the light of the closure of the Falconer Museum in 2019 while other museums remain open and supported, seems worth asking. Putting aside flippant suggestions such as "they provide shelter when it rains", "it's a place with toilets", or even, with an energy crisis looming, "it's somewhere to keep warm at someone else's expense!", some general ideas are developed here, springing from thoughts inspired by the fate of the Falconer Museum.

The concept of the Falconer Museum was first suggested in the will of Alexander, Hugh Falconer's brother, in 1856, though it would be thirteen years before the Museum opened. The will contained a legacy of £1,000 towards the project (about £85,000 in today's money, but estimates vary). This was enhanced by a legacy of £500 from Hugh himself in 1865, and by other donations from a third brother, Charles, and also three of their nieces, thus demonstrating that the museum was to be

seen as a bold statement of the Falconer brand.

In the years prior to the museum's opening, Hugh had sent home cratefuls of materials, mainly in the form of dried plants, fossils, and geological specimens from his long research and travels in India. These formed the nucleus of the Falconer's collections. It is not clear where these were stored prior to the Falconer's opening, but presumably some of the trustees appointed under Alexander's will took good care of them.

A declared purpose of the public museum was "to illustrate local life and conditions". Abbreviating this to LIVES acknowledges that museums, through artefacts, deliver snapshots of local life, which may range from ancient ages right up to the present day. Alexander's will included a clause "for displaying objects of art and science and including a library and lecture room". This was undoubtedly stimulated by Alexander having in mind the custodianship of his brother's gifts. Summarising this, we can add COLLECTIONS as a further objective for museums. Of the vast number of Falconer's fossils and plant drawings, the most important are rightly lodged in prestigious places such as the British Museum and Kew Gardens. Nonetheless, a considerable number of highly important fossils, including those connecting us with our earliest human ancestors, is stored in the Falconer.[1]

Building the Falconer Museum involved the purchase and demolition of some undistinguished houses, a development which was then viewed with public acclaim on account

1 As Torben B Ballin points out in his contribution to this anthology 'Three different species of humans', "the greatest surprise was to discover in the collections of the Falconer Museum an unexpectedly large and important assemblage of Palaeolithic flints covering several hundred thousand years of human prehistory – a collection which, on this point, matches those of the National Museum in Edinburgh, the Hunterian Museum and Kelvingrove Museum in Glasgow." "Interestingly, the three lithic industries are associated with three different species of humans, namely *home erectus*, *homo neanderthalensis* and *homo sapiens*." (Annotation by the editor.)

of its effect of widening Tolbooth Street! The architect was Alexander Reid of A. and W. Reid Elgin, with the sculptured decoration credited separately to an artist called Thomas Goodwillie. The result was a pleasing building ornamented in a style characteristic of its mid-Victorian period. In the broader sweep of social history the Falconers must have been aware that the Chambers Street Museum in Edinburgh opened in 1861 and that their donations were much in the spirit of those that brought about the construction of large museums and civic art galleries in major cities such as Liverpool, Manchester and Glasgow during the second half of the 19th century, often funded by philanthropically minded factory and business owners who had profited hugely from the fruits of the Industrial Revolution. Such elements of the built environment are now rightly seen as part of national HERITAGE. Modern in its time, the Falconer's closure is today seen as a step in the foresaking of the heritage buildings of Forres, while another, St. Laurence Church, is threatened with the same fate.

Answers to the posed question can thus be summarised as LIVES, COLLECTIONS, HERITAGE and represented as three points of a triangle, or rather as three overlapping circles based on three such points.

The overlaps are considerable. Establishing a portrait of a particular point in time usually involves gathering a collection of relevant objects, while an existing collection in itself is such an object, whether it has been gathered at one specific time or over several years or periods. HERITAGE often raises thoughts about buildings and architecture, and yet LIVES and COLLECTIONS can often be considered as part of today's heritage.

Curatorship

In the Falconer's early days, the town council and local citizens were quick to contribute items. The council for example loaned baillie robes, bronze bells, the town drum, pikes, three 'jougs' (iron collars by which malefactors were chained to a post), a cracked Trafalgar Club punch-bowl (the Trafalgar Club was formed to celebrate Nelson by building the eponymous tower). Individuals contributed items such as a spinning wheel, curling stones, an anti-poaching man trap, shells, bones, stuffed birds, even travel souvenirs from places like Pompeii.

As the treasures poured in, a person, whose name we do not know, must have taken overall charge of classifying and categorising them. Each item would have required a decision. Should it be linked with others to help create a snapshot of a particular time illustrating LIVES, or would it be better deployed with others to form a COLLECTION, in some cases demonstrating how a particular type of object developed over time? Some objects such as Hugh's large elephant skull defied such classification and commanded display in their own right (think also of dinosaurs in the Natural History Museum). Without the intelligence, experience, and powers of discretion of a skilled individual as curator, that is an overseeing superintendent, a budding museum would be no

better than a junk shop.

Modern curatorship has focused increasingly on DISPLAY and INTERPRETATION, and today's museum visitors take it for granted that objects are numbered with corresponding descriptions located on accompanying panels. Computers have certainly helped this process. Portable audio guides are a further enhancement, sometimes being necessary for understanding the exhibits.

One of the many roles of curatorship is dealing with CANON, canon in the sense of criterion or standard of judgment. No museum can contain an indefinite flow of new material, and acceptance of new items inevitably leads to the disposal or storage of others. Canon is not the only thing in constant flux. Another is changes in public attitudes which have been particularly marked in recent years. Consider the following from a museum website:

> *Visit the shop and stand at the bar. Browse the windows of the old toy shop and the pawn shop. Look into the shoe shop and the furniture shop. Peruse fashions from yesteryear in the department store. You may even remember some retail names from times past.*

It is hardly conceivable that something of this style would have been in the minds of the Falconer brothers!

How do today's visitors see museums?

This representation above allows labelling museums themselves in a kind of meta-classification, that is in broad qualitative ways according to the relative weightings of LIVES, COLLECTIONS and HERITAGE. For example, the Falconer Museum started as having LIVES and COLLECTIONS dominant in similar proportions, broadening to HERITAGE

to include the building as time went on. The Highland Folk Museum in Newtonmore represents by contrast dominantly LIVES, although arguably with a touch of HERITAGE. Similar considerations apply to New Lanark where the objective is clearly to encourage visitors to relive the past. Elgin Museum is strongly weighted in COLLECTIONS on account of the Birnie hoard, the Kinnedar stones, and the geological specimens, whereas Inverness Museum ranks higher on LIVES on account of the items relating to the Culloden period. And so one could go on making what clearly are subjective judgements about individual museums.

The interest in COLLECTIONS implies that a small minority of visitors come to museums as researchers seeking neither wonder nor interpretation but rather a base from which to increase knowledge. The existence of the information embodied in collections is, even if untapped, treasure on which future knowledge can be built. An example in the Falconer is the Keith herbarium, a beautifully documented record of Moray's flora, which is surely an opportunity awaiting some future student of climate change.

How do museums fulfil their purposes?

At the top of the range world-class palaces such as the Victoria and Albert started in 1852 as a Museum of Manufactures – pure COLLECTIONS – evolving to COLLECTIONS and HERITAGE in 1899 when the foundation stone of the present building was laid, at which point it extended its roles to include "public interpretation of art and design". To a first time or occasional visitor, the experience of immersion into the extraordinary expression of human creativity in many astounding displays is overwhelming, something which has been successfully copied in the V & A Dundee which opened in 2019. A predecessor of this sense of awe on entry might be

represented by Solomon's Temple in Jerusalem. The state-of-the-art technology applied within the V & A is itself an example of LIVES because it is a snapshot of one aspect of the present day and in this capacity will doubtless continue to evolve at a technologically driven pace. This aspect is quite apart from both the COLLECTIONS which span over 5,000 years, and, of course, the HERITAGE embodied in one of the finest Victorian buildings in Britain.

Kelvingrove Art Gallery and Museum in Glasgow was only a short way behind, opening in 1901. It too has the power to astound visitors with its stunning architecture and spell-binding large-item displays. At this topmost level civic authorities delivered a message of wealth and grandeur to the world, or to compress it into a single word: PRESTIGE. At a humbler level than for example South Kensington it is reasonable to surmise that the Falconer Museum in its time enhanced the prestige of the town of Forres, which only a few years earlier had already been boosted by the opening of a railway route to the south over Dava.

What of museums lower down the scale? The flux in public mood has resulted in greater emphasis on the ENTERTAINMENT aspect of museum curatorship. More sober perhaps has been the development of EDUCATION, something which the Moray Council Museum Service had taken up with some enthusiasm before closure. Again, quoting from a website:

> *The natural world, world cultures, science, technology, design, art and fashion, archaeology, and Scottish history – whatever your topic, bring your class on a visit to find out more.*

And from the Falconer Museum's website, referring to the time when the museum was open:

> *Lifelong learning is at the heart of all our activities and events. Loan boxes and hands-on workshops are available for groups of all ages.*[2]

There is a National Fund for Acquisitions which helps accredited museums and galleries as well as libraries and archives throughout Scotland to make acquisitions for their collections, provided they are open to the public and not run for profit. The funding can cover everything: art, animals, Ancient Egypt or Charles Rennie Mackintosh. National Museums Scotland manages this fund on behalf of the Scottish Government. However, as with canon in the case of the content of individual museums, canon also applies to the National Museums' total portfolio of museums. A similar consideration applies to Scottish castles which draw visitors to Scotland. But organisations such as Historic Environment Scotland and the National Trust can afford to maintain only a finite number of them, and so some are left to perish, a notable example in the local area is Inshoch Castle near Auldearn.

Who should pay for the off-canon museums?

The closure of a major heritage building in Forres in 2019 provokes the above question. Museums are in a state of constant flux. Victorian-style philanthropy at one time played an important part, reflected in the vision of the Falconers' donation to Forres, sadly without an endowment. The Falconers bestowed on the town a handsome building to act as

2 "These boxes are full of objects to handle, documents, and photographs to look at and ideas for classroom activities. Available to borrow for a 4-week loan period and delivered to your school. This is a good chance for the children to have a hands-on experience within the chosen topics. If you would like a box please don't hesitate to contact the museum." http://falconermuseum.co.uk/learning-and-resources/

a repository for its citizens to fill with items which they deemed to be of heritage value and worth making public: their gem stones, archaeological and antiquarian finds, craftsmanship items such as clocks and jewellery, and of course stuffed birds and mammals. Examples of similar buildings bestowed by rich philanthropists are to be found throughout the UK; notable in Scotland are those gifted by Andrew Carnegie. Payment for heritage was initially a matter of public-spirited citizens offering their treasures for static display, while the trustees saw to it that the building was kept in good order.

Fast forward to the end of World War II, and there seemed to be no reason to abandon this pattern with the costs borne by the town council as part of what Forres householders paid for through their rates. In time the burdens of financial squeeze on the one hand and financial expectation on the other forced councils to prioritise 'essential' activities, such as clean streets, safe public spaces, fire and police services, children's schooling coming before 'leisure' activities. The barrier of affordability rose and eventually heritage was left unpaid for, overriding any legal obligations. Unpaid for, that is, by public authorities; but in the case of three of Forres' other heritage buildings, paid for in kind by the considerable volunteer efforts in Town Hall, Tolbooth and Nelson Tower.

The sociology of a museum

Those with local memories of the post-WWII era recall the Falconer Museum of that time as a somewhat gloomy and not much visited repository for an assortment of artefacts mainly in glass cases, the most conspicuous being those containing stuffed animals. Yet local rates comfortably accommodated the costs of running the museum whereas nowadays, in vastly more prosperous times, after the expenditure of much voluntary and professional effort to make the collections and

their presentations more attractive, promoting both, education and entertainment, it appears to be beyond the resources of a local government. Considerable volunteer effort and public money has been invested in the past and brought the Falconer Museum to modern standard, promoting both, education and entertainment. For example, in 2004, Moray Council, with the help of Heritage Lottery Funding, spent more than £353,000 upgrading the museum building and store, so collection items could be stored in environmentally controlled conditions and exhibited in quality display cabinets.

The great museums derive their fame and public subsidy from relatively small numbers of outstanding objects – for example the Elgin Marbles in the British Museum or the spacecraft in the Smithsonian in New York. The former raises the question of whether, now that technology can create exact replicas, there is a case for returning the Elgin Marbles to Greece. Looking forward it is becoming increasingly possible to 'visit' museums and their individual items on smartphones and similar devices. Technology might at first sight seem to be a way to hasten museums on the road to redundancy; but paradoxically technology has the effect of stimulating the desire to see the real thing, especially at a time when travel opportunities have never been greater. The public flock, often from across the world, in great numbers to special exhibitions assembled by major galleries and museums.

Where does this leave us?

Sadly, these thoughts are more about questions than answers. People look in sorrow on a handsome building housing a museum which so recently showed promise of growth, of which the only present sign is a sapling growing out of the gutter! The Falconer alas is a victim of the understandable inability of its owners to pay for its upkeep, although it would

seem incumbent on them to provide care for the collections, where denial of public access is both a betrayal of past trust and a barrier to potential research. In every advanced society the accumulation of great wealth by a successful small minority of super-rich families and individuals has been economically inevitable, whether their fortunes derive from business, inheritance, or most recently from sport or pop music. In the middle to final quarters of the 19th century there was a pleasure in philanthropy which a hundred years on, with a few notable exceptions, has been replaced by pleasure in possession – super-yachts, mansions, premier football teams and so on, in a single word, greed. Wizardry in display and international prestige has assured the top museums of continued support in their roles. Meanwhile, public mood and sentiment militates against the model of many small-scale museums specialising in either themes or localities which previously secured the Falconer's place in the fabric of life in Forres. Public appetite favours show and splendour leading to centralisation and neglect of smaller museums which do not make it into the top league. How can restoration and renewal come about? – A currently unanswered question.

About the author

Norman Thomson is a retired statistician who came to live in Forres in 2006. He is a co-founder of the Moray Way Association, and author of the recent Moray Way Companion. *He has also written* The Forres Companion *and the* Dava Way Companion *and is a past chairman of the Moray Field Club. He is a trustee of the Dava Way Association and of Forres in Bloom, and a member of St. Laurence Church, Forres.*

IN SEARCH OF
HUGH FALCONER

A coat of many colours

Falconer, man and museum

Ruth Fishkin[1]

In the autumn of the year 1837, an ageing Forres couple received a letter from their son. "You would not know me", it read. "I am dressed ... after the fashion of these parts." That Forres couple probably had no way to picture what their son was wearing; it is quite likely they had never seen an image of anyone dressed in the fashion of the Himalayan foothills. The young man who wrote to them had travelled by the fastest known method, but it had taken him five months to get from Scotland to his destination.

Hugh Falconer was born in Tolbooth Wynd, grew up and went to school in Forres; and then his energy and multifaceted talent drew him onwards into the wider world. By the age of twenty-two, in 1830, he had attended two Scottish universities, qualified as a doctor, and travelled to Bengal as an assistant surgeon with the British East India Company. By 1831, he had arrived in northwestern India, stepped out of his tent, and ricked his ankles on the area's rich supply of fossils. By 1832 he had turned himself into a palaeontologist, helping to

1 This is the revised version of an article which was first published in *Knock News*, 54/55, February 2020.

invent a brand-new science, as yet unnamed.

This was the beginning of the age of the Victorian self-taught scientist. Science as we know it lay heavy in the womb of the Enlightenment. Western thought had absorbed too much logic, too much increasingly accurate data, too much communication with itself and the rest of the world, to remain contained in the belly of mediaeval world view. As the young Falconer set sail for India and the young Darwin embarked for the Galapagos, the contractions were starting.

The physician Hugh Falconer assisted at the birth of deep time in Western thinking. Falconer was a medical doctor, a professional botanist (he ran, at different times, two botanical gardens in India), a geologist and palaeontologist, and one of the founders of what would come to be called archaeology. Given all the different fields that his mind seems to have been capable of ploughing simultaneously, perhaps it is no surprise that to Western science his most acknowledged insight now is the concept of punctuated equilibrium in evolution. A century later, palaeontologist and biologist Stephen Jay Gould would articulate this theory, referring to Falconer and bringing the idea of punctuated equilibrium to world-wide recognition. Falconer noticed that evolution happens in a series of fits and starts, with periods of stasis in between.

Perhaps his own life was like that. It must have been, for a man of great personal generosity and phenomenal intelligence in an imperfect world.

Falconer's Indian fossils now form an arm of the Natural History Museum in London. As a benign afterthought, it seems, he left money and those parts of his collection which had landed in his birthplace to help build and establish the museum which bears his name. Its financing was assisted by a brother, Alexander. The Falconer Museum opened a few years after Hugh's death and has been part of Forres ever since.

Hugh Falconer emerges from letters of his colleagues as an awfully nice man. He seems to have been better at being

a catalyst for the work of his contemporaries than at claiming credit for his own discoveries. One of these friends wrote in the 1850s: "Falconer gave me a magnificent lecture on the age of man ... we are not upstarts ... We can boast of a pedigree going far back in time, coexisting with extinct species." The writer of this letter was Charles Darwin, whose publication of *The Origin of Species* was drawing nearer.

It was Falconer who rushed back from Gibraltar in ill health to support Darwin's claim to the Copley Medal in 1864. He was like that. Falconer died a few weeks later, on 31 January 1865 at the age of 56. His grave can be found in Kensal Green Cemetery in London.[2]

Do you like tea? You can thank Falconer for that. It was on his recommendation that tea-growing was initiated in India by the East India Company, making the drink available to all. Previously it had been beyond the reach of many people in Britain and the wider Western world. All the tea in China may be a fine thing, but all the tea in India – that is Falconer's gift. Would you prefer gin and tonic? He was instrumental in the cultivation of plant sources of quinine, the vital ingredient of tonic water (and also responsible for saving thousands of lives as the most effective treatment for malaria before modern antimalarial drugs). Do you like the great woolly mammoth of the North American Ice Age? Falconer identified it, and named it *Mammuthus columbi*, the Columbian Mammoth.

If the character of Falconer had been different and he had had more interest in promoting himself, it might have been called *Mammuthus falconeri*. We might have as well the Falconer giant tortoise, the Falconer stegodon, the Falconer extinct ape, the Falconer tea company and ... and the Falconer Museum, his dear legacy to his home town, might not now be closed.

2 More information on Hugh Falconer's grave in Scott Keir's contribution to this anthology, 'What to bin and what to keep'.

Hugh Falconer never married and left no children. He did however have nieces, who in his later years were valued correspondents[3], and it is one of them who left her uncle's Himalayan ceremonial robe to the museum he founded. If Isabella Milne left a note, too, it has not survived with the garment. As so often happens, we do not have the story of the thing, just the thing itself and the knowledge that it was his. And we have the understanding the study of the thing itself can give – to us, to our children, to our children's children. The robe has never been examined by an expert. If this artefact survives another generation, maybe then it will be able to tell its story through techniques now undreamed of. Falconer's science knew nothing of radiocarbon dating, isotope analysis, or scanning electron microscopy. Generations after dumbly joining the museum's collection, the robe still has tales to tell. The things themselves can speak when we know how to listen.

This silk gown is the thing itself. The yellow silk is still gorgeous, the silver thread filigree a few shades darker and going on two centuries older than when Indian hands stitched it and the great scientific son of Moray wore it. The robe is a thing of beauty, and the brilliant and generous spirit of Hugh Falconer still inhabits it.

Want to see it? Oh, dear – you can't. The museum is closed. Want to see the quarter-million-year-old Acheulian hand-axes Falconer brought back from their French type-site, in the dawning light of recognition that the biblical 6,000 years simply won't accommodate human prehistory? They are stunning and fit in a *Homo sapiens* hand as comfortably as in the grip of their *H. heidelbergensis* makers. Ooops… no can do. The museum is closed.

Want to see the other treasures that the Falconer legacy to the people of Forres has collected and saved over the past 150 years for you, people of Moray and of all the world?

3 Notably Grace Milne, see 'Connecting with our geological past' by Alison Wright and 'Letters to a niece'.

The 3,000-year-old sword of your ancestors, deliberately broken in some Bronze Age social crisis and sacrificed in a nearby bog? It was the single most materially valuable object in their world, and they smashed it and put it beyond use, into the watery other-world below the surface. Do you want to look at it and imagine, maybe understand, why your ancestors did that?

The Corries' guitar? It's Roy Williamson's guitar, maybe the one on which 'The Flower of Scotland', the unofficial Scottish national anthem, was composed.

The Neolithic ceremonial mace head? It is so pristine after 6,000 years that it can't have managed one dented skull in all that time.

The local shop's early 20th century spools of knicker elastic, as your great-granny bought it (by the yard, in various thicknesses)?

Want to see them?

Oh, dearie. You can't. The museum is closed. It's closed.

NB While the substance of this article is accurate, the writer has had to estimate a few of the dates and take the quotations from her notes as it is now impossible to access the sources since the museum is closed.

Oh, dear. Perhaps a nice consoling cup of... oh, dearie, dearie me... Darjeeling.

About the author

Ruth Fishkin has lived in Forres since 1999 and been a museum volunteer since 2011. She is a past vice chair and current committee member of the Friends of the Falconer Museum. Her work (past, present, paid, unpaid, and for love) includes archaeology, counselling and psychotherapy, writing, museum curation and conservation, jewellery-mending and general survival on the fringe of the socio-economic bell curve.

A Who's Hugh of Aberdonian science

Or: Dwarf elephants at the British Science Festival

Dr Victoria Herridge, 2012[1]

What do you get if you put Aberdeen, the British Science Festival, and dwarf elephants together? Isn't it obvious? Hugh Falconer, of course.

What do you mean you've never heard of Hugh Falconer? The man who was instrumental in introducing tea plantations to India? The man who, in 1842, brought back five tons of fossil bones to the UK from Pakistan and India, fossils which would eventually form a core part of the Natural History Museum's collections? The man who Stephen J. Gould claimed was the first scientist to anticipate the evolutionary theory of punctuated equilibrium? Not ringing any bells? Poor Hugh Falconer – one of the most respected scientists of his

1 Victoria Herridge wrote this short piece as invitation to her talk at the British Science Festival in Aberdeen in 2012. It first appeared on the British Science Festival Blog under https://britishsciencefestival.wordpress.com/2012/08/24/a-whos-hugh-of-aberdonian-science/ and can now be found on the author's website under https://toriherridge.com/tag/hugh-falconer/ Reprinted with kind permission by the author.

day, but now he is largely forgotten.

Well, this year, at the British Science Festival in Aberdeen, it is time to remember him. Not only did Falconer began his academic career studying Natural History at the University of Aberdeen (class of 1826), but this year is also the 150th anniversary of the first-ever scientific description of a species of dwarf elephant. Guess who described it. Yep – Hugh Falconer, and he did so at the 1862 Annual Meeting of the British Association of Advancement of Science, the forerunner of today's British Science Festival.

As if that wasn't coincidence enough, I am bringing dwarf elephants (or, at least, their fossilised remains) to the festival, just like Falconer did back in 1862, to talk about their evolution and what we have – and haven't – learnt in the last 150 years.

Falconer's dwarf elephant fossils, which he called *Elephas melitensis*, were from Malta. Other dwarf elephant species (all sadly extinct) have since been discovered on Malta, Sicily, Sardinia, Crete, Cyprus and many of the small Greek islands (like Rhodes and Tilos), as well as on the Californian Channel islands and on Wrangel Island in northeast Siberia. They are an example of the phenomenon known as the 'Island Rule', where big animals evolve to get smaller, and small animals evolve to get bigger.

Descended from a 4m-tall, 10-ton extinct species of elephant known as the straight-tusked elephant, Falconer's elephant would have stood just one metre tall as an adult, the size of a newborn African elephant today. Living alongside it on Malta were a giant dormouse, and a giant swan that probably topped the little elephant in height (the swan, that is – the thought of this, I must admit, scares me slightly). I'm interested in understanding how and why elephants evolved to be smaller on islands, and to help do this I am gathering evidence to find out how old the fossils are. We think most of the Mediterranean dwarf elephants lived sometime between

800,000 and 10,000 years ago, but we lack more exact dates for each species. Once I have this information, I'll be able to place the dwarf elephant fossils into the context of the climate changes of the past and see whether these were important to their evolution and extinction.

There's good reason to suspect climate change might have been important, because these dwarf elephants mostly evolved during a period characterised by big climate fluctuations, with warm stages (like today) switching to ice ages, or 'glacials', every 100,000 years. Glacial climate, as Hugh Falconer wrote to Charles Darwin (in September 1862, in fact), was ". . . no joke: it would have made ducks and drakes of your dear pigeons and doves". But for islands it had another significant effect: the sea level would drop as water became frozen at the poles, opening up routes to islands, and increasing their size. With the converse being true of warm stages, it is immediately apparent that the island environments, and the species living on them, could have been affected by these fluctuating climate changes. In my talk at this year's Festival, I will be exploring this further, with some help from the audience.

There won't be much room for Hugh Falconer in my talk, but it's his work from 150 years ago which underpins it. So, if you're in Aberdeen this September, please do spare a thought for the boy from Forres who became a man of science in Aberdeen and did so much more for science than just describe a species of dwarf elephant. File him in your mind alongside Darwin, Hooker, Huxley, Lyell, and Owen – he managed to fight with them all at one time or another – and think of him each time you have a cup of tea. And if you can spare the time either side of the festival, go to the Falconer Museum in Forres to find out more. It's only a couple of hours up the road, after all.

About the author

Biologist and palaeontologist Dr Victoria 'Tori' Herridge is Daphne Jackson Research Fellow at the Natural History Museum in London and one of the founders of TrowelBlazers, which celebrates women archaeologists, palaeontologists and geologists. She is Editor-in-Chief of Open Quaternary and TV presenter and broadcaster. Her website: toriherridge.com

Hunting for Hugh Falconer's notebooks in Forres...

A request for help

Dr Victoria Herridge, 2012[1]

Hugh Falconer was the first person to describe a dwarf elephant (150 years ago, in 1862). He was pretty terrible at publishing, however, and this is making my work on sorting out the messy state of Sicilian and Maltese dwarf elephant taxonomy rather tricky.

After his death, his friends turned his notes and letters into a book as a way to make up for his lack of lifetime publication. It ran to two thick volumes! There must have been a huge pile of papers and notebooks – but the originals seem to be lost. I went to the Falconer Museum in Forres to see if anything was hiding in the archives.

Forres, by the way, is better known for its association with Shakespeare's Macbeth: Duncan's castle was in Forres, and

1 Reprint of this request with kind permission by the author. It can be found on her website: https://toriherridge.com/2012/08/02/hunting-for-hugh-falconers-notebooks-in-forres/

the three witches toiled and troubled thereabouts. Judging by the witches' stone on my walk to the museum, they'd have met a sorry end had the locals got hold of them. An information plate has been attached to the stone; its inscription reads: "From Cluny Hill witches were rolled in stout barrels through which spikes were driven. Where the barrel stopped, they were burned with their mangled contents. This stone marks the spot of one such burning." Nice.

I didn't find the notebooks, but I did get to see some other rather wonderful things that really brought Hugh F to life for me, in all his larger-than-life glory. He sounded like he was a lot of fun, rather infuriating at times, but loyal and loving (if a little unreliable!) ...

If anyone has any thoughts as to the whereabouts of Hugh's notes, do let me know. I've checked with the archives of George Busk (his great friend) and Charles Murchison (who edited the *Memoirs and Notes of HF*) and looked in the Natural History Museum archives. I've also asked at Edinburgh and Aberdeen university, and the Linnean Society. Some letters survive in the Darwin archive (they are very poignant... poor Hugh seems to have waited in rather wistfully for Charles D to visit, only to be continually disappointed), but otherwise I'm at a dead-end.

Anyway – a few treats from Hugh Falconer's archive, courtesy of the Falconer Museum in Forres (which you should visit if ever you're in Scotland). All photos are © Falconer Museum.

Hugh Falconer writes in a letter to his niece Grace that he survived an incident at the Geological Society, thanks to his hat.

> "Place me on Grafton's marbled Steep,
> "Where nothing save the waves and I,
> "May hear our mutual murmurs Sweep
> "there – pig-like – let me grunt and die,
> The last of Hip-po-po-ta-mi."

Hugh Falconer identifies with a hippopotamus.

About the author

Biologist and palaeontologist Dr Victoria 'Tori' Herridge is Daphne Jackson Research Fellow at the Natural History Museum in London and one of the founders of TrowelBlazers, which celebrates women archaeologists, palaeontologists and geologists. She is Editor-in-Chief of Open Quaternary and TV presenter and broadcaster. Her website: toriherridge.com

Founding father of the new science of palaeontology

Hugh Falconer seen from an Indian perspective

Dr Vijay Sathe

In India, there are hardly any significant historic accounts available that directly refer to the occurrence of fossilised relics of prehistoric animals. Mention must be made here of the compendium of Muslim rulers in early India titled *Tarikee Ferishte* (1360 CE), written by the medieval historian Mohammad Ferishta, who refers to the discovery of bones of giants near Haridwar in 1360, during one of the canal projects started by Emperor Feroze Shah Tughlaq. Much further back in antiquity, Apollonius of Tyana, a Greek neo-Pythagorean philosopher who travelled to the southern foothills of the Himalayas in northwest India in the 1st century CE, reported that the countryside was full of dragons. Philostratus who in the 3rd century CE compiled the biography of Apollonius, describes the wealth of dragons Apollonius had referred to. Today we know that they are actually the fossilised skulls, jaws, and skeletons of gigantic herbivores of the Tertiary

period. The eye sockets of these skulls were filled with large glittering calcite crystals and tubular selenite crystals, which glitter at night and could thus be perceived as dragons.

Except these indirect references, until the 1820s India remained a *terra incognita* as far as the knowledge of fossil potential is concerned. A quick look into the scientific enquiries of that time reveals that the earliest discoveries were made by colonial irrigation engineers working at the foothills of Himalayas, by the king of the princely state of Nahan, by collectors and magistrates, by employees of the armed forces or by doctors, normally in collaboration with local people who made numerous collections of fossils in the region. This collective exercise was to culminate in developing museum collections, generating discussions regarding their zoological and geological implications. However, there remained a desperate need for an expertise to decode the zoological knowledge from these faunal relics frozen in time.

It is in this context that the arrival of Dr Hugh Falconer, assistant surgeon, and trained botanist in the service of the East India Company in Calcutta (now Kolkata) is regarded as the most significant milestone in the history of the palaeontology of India. Early in 1831, Dr Falconer got a posting to Meerut, which was at the time an important army station in northern India, in modern day Uttar Pradesh. This happened to be his first and last military duty. It required him to accompany a party of invalids from Meerut to the sanitorium at Landour in the Himalayas. On his way to Landour in April 1831, Dr Falconer happened to pass through the town of Saharanpur where he met Dr Royle, the superintendent of the Botanical Garden. Both Royle and Falconer shared a deep love for botany and natural history and these common pursuits acted as a strong bond between the veteran botanist and the rising palaeontologist. On the verge of retirement from service, Dr Royle recommended Dr Falconer as his successor at the Botanical Garden at Saharanpur, which is today popularly known as Company Bagh.

The way Dr Falconer cultivated his expertise on India's extinct fauna is simply phenomenal. His ensuing long field expeditions in association with Proby Cautley in the Siwalik hills south of the Himalayas searching for fossil remains of extinct fauna were extremely rewarding and proved to be of great bearing for the evolutionary history of large vertebrates of the Indian subcontinent. His collection was swelling at an amazing speed which also demanded constructive efforts to decode the history hidden in them. On one such occasion of an extraordinary yield of fossils, he wrote to James Prinsep who at the time was secretary of the Asiatic Society of Bengal and instrumental in coordinating the fossil collections. Falconer shared his luck of finding a huge cache of fossils in a day in the Siwaliks. On 3 January 1835, he wrote:

> *"Only conceive my good fortune: within six hours I got upwards of 300 specimens. This was on November 20th; a couple of days after Lieutenants Baker and Durand had got their first specimens through the native collectors".*

Falconer had learnt the art of finding solutions to any problem that confronted him! In the face of their collection growing larger and skeletal diversity demanding systematic osteological and taxonomical designations of these fauna, he was aware that he needed modern collections and literature for comparative anatomy, which was not possible to obtain so far away from London. However, Dr. Falconer and Captain Cautley *"soon found a museum of comparative anatomy in the surrounding hills, plains, and jungles"* by means of resorting to the hunting of animals like tigers, buffaloes, antelopes, cattle, deer, and other Indian mammals. The skeletons of the hunted animals were preserved and compared with the ancient fossil finds. As Dr. Falconer and Cautley made greater headway in their scientific pursuits, their discoveries within the Siwalik ranges came to be referred to as the 'Siwalik Fauna'. Though

he primarily undertook extensive palaeontological expeditions in the Siwalik hills, Falconer's investigations in the Yamuna valley, Piram island and the Gulf of Cambay, and the Narmada and Betwa river valleys were also of great value; they brought to light finds whose distribution shows a case of faunal succession in Peninsular India.

As Dr Falconer's and Captain Cautley's quest for Indian natural history became more intense, his prolific writings became more and more important, especially while the world of palaeontology still had very little knowledge of the scientific potential lying locked in layers of earth in the Indian subcontinent. Soon, the gentle rays of recognition and accolade by British scientific circles began to shower upon Falconer and Cautley. In 1837 the award of the prestigious Wollaston Medal instituted jointly upon them in the year 1837 marked their contributions and acknowledged their hard work in extremely difficult terrains, and in disciplines where knowledge and its synthesis was entirely a maiden exercise. The Asiatic Society of Bengal was gratified in no small measure by the achievements of two of its illustrious members. In his congratulatory letter to Dr Falconer and Captain Cautley, James Prinsep, the Secretary of the Asiatic Society wrote:

> *"The honour to yourselves is the more flattering because it is disinterestedly bestowed, and as honourably won by the real merit of your researches **in a field of your own discovery**, and in a country hitherto supposed barren of fossil remains."*
> (editor's highlight)

In the same letter, Prinsep made a special address to Dr Falconer, the relevance of which is historic:

> *"I shall not fail to make known the zealous continuation of your joint researches crowned by the discovery of a gigantic fossil ape,*

the nearest approach to fossil man that has yet rewarded the labour of Geologists."

Hugh Falconer's first tenure lasted twelve years, after which the fossils were transported to London. Then began a long period of 15 years of painstaking research and prolific writings which he undertook while in London and travelling in Europe, before returning to India for a next and briefer tenure. He became superintendent of Calcutta Botanical Garden in 1847, having to finally leave India in 1855 because of ill health.

Though the credit for the discovery of the first fossil evidence of primates *(Quadrumana)* in 1837 is given to Edouard Lartet, a French lawyer and amateur palaeoanthropologist, this appears to be a case of historical error. Prior to this announcement, Falconer and Cautley had already discovered jaw, canine and ankle bone of primates, which they found comparable with modern day *Semnopithecus* and *Pithecus rhesus*. The discovery was perceived as evidence of the progressive development of organic life, for which Charles Lyell had lacked substantive evidence.

Based on his research experience and in-depth knowledge of the landscape, Falconer was confident that India had the potential of yielding human fossils and being the cradle of mankind. Two of his papers titled 'Primeval man and his contemporaries' and 'On the assorted occurrence of human bones...Nile and Ganges' are apparently autobiographical in nature but reflect his conviction of finding them in future investigations. His foresight proved right about 140 years later in 1982, when in the Narmada valley in central India the first human fossilised skull was reported. It has been designated as an archaic *Homo sapiens* and, along with a few subsequently discovered limb bones, continues to be the only fossil record of prehistoric man in India.

Falconer's reputation as epitome of scholarship has rarely been doubted and continues to be valid even in the 21st century. This includes his ideas on human evolution. Stephen Jay Gould,

one of the world's pioneering palaeobiologists acknowledges Falconer in his late 20th century works on human evolution as the greatest palaeontologist of the 19th century, noting that Falconer had already anticipated the core notions of his own theory of punctuated equilibrium more than a century earlier.

One of the most significant contributions of Dr Falconer is probably the joy of a cup of tea that every Indian enjoys in the morning as well as at any other time of the day! With his intimate knowledge of environmentally, pedologically, and agriculturally conducive landscapes across the continent, he concluded that the tea plant may be successfully cultivated in India, although not in the plains but from a latitude of 30 degrees N., north of Calcutta. He identified the Himalayan mountains of that latitude where the climate could be similar to that of the tea plantations in China. His experimentation with planting tea was a gift to every tea lover in the subcontinent and more importantly, it enabled India to become a major tea exporter to Europe, with a cost effectiveness previously unseen. Tea had erstwhile been an exotic import from China and Britain depended on tea from China for its entire supply. It was a moment of pride for Falconer when he saw that the premier quality of the new tea from India would match with that of China. He reportedly said, *"My tea services are undeniable"*, which is more than justified.

As a trained botanist, he published several papers with the Linnean Society. Special mention must be made of his work on the plant *Aucklandia costus* which was found growing wild in the valley of the Astore, one of the tributaries of the Indus. His recommendation for its plantation in other parts of the continent has given India the gift of asafoetida which is the dried latex exuded from the rhizome of the tap root of the species and a flavouring spice in a variety of foods in India. It is used as a digestive aid, in food as a condiment and also in pickles. Ancient Ayurveda recommends it for many diseases, and it can be found practically in every Indian kitchen today.

Falconer's contributions to Indian forestry and railways as well as tea and asafoetida stand as tall testimony to his versatile character and academic acumen.

India has benefitted greatly from its careful and vivacious use of his knowledge.

Dr Falconer was familiar with the traditions of Indian culture and mythology. He named fossil species of hippopotamus, elephants, giraffes, rhinoceros, deer, horses, etc. after the Hindu Gods, as they were discovered in the Siwalik formation, wishing to *"commemorate this remarkable formation so rich in new animals"*. Dr Falconer and Cautley noted that the Siwalik or the sub-Himalayan range of hills was considered in Hindu mythology the roof of Siva's dwelling and the whole tract between the Jumna and the Ganges, the habitation of Lord Siva, hence the naming of *Sivatherium giantiuum* for an extinct giraffe. Their naming of the massive tortoise *Colossochelys atlas* refers to the giant tortoise *(kurma)* of the Hindu mythology. The ancient texts *Satpatha Brahmana* and the *Bhagavata Purana* mention a massive primeval turtle. The former text considers the giant tortoise to be the incarnation of *Prajapati* (Lord of the world) whereas the latter allies the tortoise to the *Puranic Visnu*.

The *Bhagavata Purana* furnishes a fascinating account of the episode of the *Samudramanthana* (the churning of the ocean). As the gods *(devas)* and the demons *(asuras)* churned the ocean in a frantic bid to seek ambrosia *(amrta)*, Lord Visnu assumed the form of a colossal tortoise *(Kurma)* to support the mount *Mandara*, which served as the churning rod. As per the *Bhagavata Purana* the *Kurma avatar* (tortoise incarnation) was the second among the ten avatars of Visnu, the first being the *Matsya* (fish) and the third being a boar *Varaha*. Dr Falconer also alludes to another story from the *Mahabharata* where *Garuda*, the divine vehicle of Visnu, went to *Chandraloka*, where it witnessed a violent tussle between a giant tortoise called *Vibhavasu* and an elephant named *Supritika*. Unable to stop the contention,

Garuda caught hold of them and ate them both.

Dr Falconer attempted to find some connection between the fossil record and the Puranic myths, which were deeply entrenched in the minds of Indians, as the cardinal truths about the Almighty acting as the supreme Saviour by assuming various forms. Dr Falconer was well versed in the traditional Indian customs and the relationship between the student and his teacher (*guru*). He understood the meaning of *guru* and held it in utter reverence. That he permanently imbibed the meaning of it can be seen in one of his letters, of 9th August 1864, many years after he had left India! Prof Pruforth invites Dr Falconer for dinner for his 84th birthday and Falconer replies: *"Yes, provided you promise to demean yourself, i.e. if Guru can really do so"*. It speaks of the humility, respect, and admiration he held for his seniors and teachers that he chose the term *Guru* of Indian philosophy and wondered how a teacher could demean himself by inviting his student or a junior person for dinner!

Dr Hugh Falconer was one of those great naturalists of the 19th century, a contemporary of Charles Darwin, whose meticulous study of the fossils of the Siwaliks put this country on the global palaeontological map. His devotion was such that the frozen vestiges of life that he saw around him became alive for him. It was Dr Falconer who infused these dead remains with scientific meaning and relevance. His work is still relevant today and widely quoted. In fact, no systematic palaeontological study on vertebrate fauna can be complete without referring to his volumes of *Fauna Antiqua Sivalensis* and other beautifully illustrated research papers and monographs that stand as a tall testimony to his genius. Cautley, an expert field geologist and engineer, and Falconer, a trained natural historian: together these personalities could negotiate and 'translate' between various epistemic spaces ranging from the field, the laboratory, the museum, and the lecture hall, with the aim to disseminate knowledge for posterity. The two

were able to cooperate despite the difference in their visions of what science in essence should be. Cautley owned the most extensive collection of Siwalik fossils and Falconer had the tools needed to make sense of it, both geologically and zoologically. The name of Dr Hugh Falconer is deeply etched into the history of science in India with special reference to fossils, horticulture, forestry, and human evolution. A true polymath, Hugh Falconer is duly recognised as the father of the palaeontology of India, his works ready lessons to anyone wishing to understand and investigate the history of life in India with special reference to the Cenozoic period of geological history. It is fitting here to quote Stephen Jay Gould, who in his tribute to Hugh Falconer concludes:

"If Hugh Falconer had not died before writing his major and synthetic works, he might be remembered today as perhaps the greatest vertebrate palaeontologist of the late 19th century".

Dr Vijay Sathe standing next to the bust of Hugh Falconer during his visit to the Falconer Museum in Forres in 2019

References

Communication with India has its challenges, even in the age of the internet. A full version of this article, including references and literature, is in preparation to be published on the Falconer Museum website.

About the author

Dr Vijay Sathe teaches at Deccan College Postgraduate & Research Institute, Pune, India, Department of Archaeology. He visited Forres in 2019 to undertake intensive studies on the Falconer Museum collections of Indian palaeontology.

For all the tea in China

A true tale

Anne-Mary Paterson[1]

Caffeine in the form of tea is a drug – as is opium. The latter is many times more powerful, but the two are very much connected.

Nowadays we think of tea as mostly coming from India, but in the seventeenth century, the tea that people drank in Britain came from China. The first written reference of someone drinking tea in this country can be found in Samuel Pepys' diary entry on 25 September 1660: "And afterwards I did send for a Cupp of Tee (a China drink) of which I never had drank before".

First imported by England's old ally, Portugal, tea in Britain spread to fashionable circles following Charles II's marriage to tea addict, Catherine of Braganza, in 1662.

1 I came across the story in my research into Sir Alexander Matheson, a founding partner of Jardine Matheson, whose biography I am writing. These are the books in which I found the information: Keswick, Maggie 2008: *The Thistle and The Jade: A Celebration of 175 Years of Jardine Matheson*. London: Frances Lincoln. Grace, Richard J. 2014: *Opium and Empire: The Lives and Careers of William Jardine and James Matheson*. Montreal, Ca., et al.: McGill-Queen's University Press. Wilson, Les 2021: *Putting the Tea in Britain: The Scots Who Made Our National Drink*. Edinburgh: Birlinn.

The British East India Company had a monopoly on trade east of the Cape of Good Hope, South Africa, and therefore were the sole shippers of Chinese tea to Britain. The imports from China of tea, silk, luxury goods, and a few other products meant that, apart from small quantities of cotton the other way, there was a trade deficit with China.

The Chinese were anxious to get as much silver coinage as they could by trading with the East India Company, which in turn did not wish to harm its Chinese relationship by selling them opium, an illegal product. In the latter part of the 18th century opium was illegal in China; but a non-addictive version was in general use, even, it was said, in the emperor's court. In Britain, opium was a popular and legal drug used in medicines like Godfrey's Cordial for soothing babies. For adults there was a mixture of alcohol and opium called Tincture of Laudanum, used for pain relief and many other complaints. To solve their trade problem, the East India merchants sold opium grown in India at the harbour of Calcutta to companies who guaranteed that they would only take it to China.

Situated at the far end of Asia and cut off from the rest of the world by mountains and the Great Wall, only a tiny piece of China called Canton, now Guangzhou, on the Pearl River northwest of Hong Kong, allowed entry to foreigners. It was from here that tea was exported.

The company which carried out most of this trade was Jardine Matheson, which made its first delivery of tea to London in 1839. Depending on the weather, it could take two months to travel from Canton to Calcutta and a further four to six months to travel from there to London.

Tea was becoming a more popular drink in Britain. But with the difficult relations between Britain and China at the time of the First Opium War (1839–1842), exporting tea became a problem. New ways to trade tea needed to be found. The obvious place to grow tea, if possible, was in the

mountainous parts of India, which were at a similar altitude to tea plantations in China. From India, delivery to Britain would be quicker. Expansion of the trade would also not be a problem as it would now be under British control. But how could this be done as China was very protective of its tea production – and its tea plants?

In 1834 a Commission of Bengal had already asked Hugh Falconer, at the time Superintendent of Saharanpur botanical garden, to investigate how tea plants could be introduced in India. Falconer, who came from Forres in the northeast of Scotland, had first studied natural history at Aberdeen University and then medicine at Edinburgh. These two disciplines often came together in horticulture because many of the drugs used in medicine at that time were plant based.

Tea seeds have a very short viable life as botanist Robert Fortune (1812–1880) found when he was on plant-hunting trips for the East India Company in the 1840s. Fortune was responsible for introducing many new plants to the gardening world. He travelled around China in native costume so as not to be noticed because foreigners were restricted in the places they could visit. The tea seeds he sent to Hugh Falconer did not germinate.

Unfortunately, Fortune could not send tea plants as that was not allowed by China. But he found a way around this. He often used Wardian bottles to send plants he had collected. These were of various shapes, but usually took the form of sealed glass flasks with the plants' roots in damp soil. So, Fortune put mulberry seedlings which were allowed for export, in a flask and then sprinkled tea seeds over the soil. The Chinese authorities had no idea what was going on. By the time the flasks reached India, the smuggled tea seeds had germinated. Falconer planted the young seedlings in the foothills of the Himalayas. He requested more as this way of sending seed, though illegal, was so successful.

On his expeditions in China, Fortune noticed that the processing of tea was rather complicated and labour intensive. If India were to break into the market with good tea, he needed to try to do something about it. With the aid of a Chinese friend, he was able to recruit eight men who knew the processes and could teach them in India.

And so, the Chinese monopoly of growing tea was broken, thanks in many ways to Hugh Falconer.

About the author

Anne-Mary Paterson is a Scottish book author. She writes mainly about the Highland Railway and has had three books published: Pioneers of the Highland Tracks – *a biography of her great granduncles William and Murdoch Paterson,* Spanning the Gaps – *about the bridges and viaducts of the Highland Railway, and* Lairds-in-Waiting: Highland Railways Private Stations and Waiting Rooms and the Families who Used Them. *She also writes articles for magazines mainly on Scottish subjects. She lives near Inverness. Her website: https://www.annemarypaterson.com*

Connecting with our geological past

Grace, née Milne, niece of Falconer, wife of Prestwich

Dr Alison Wright

On 18th December 1832, Hugh Falconer's sister, Louisa, gave birth to her first child, Grace Anne Milne. Grace's father, James, came from a prominent Findhorn family and she grew up in comfortable surroundings at Abbeyside, now Kinloss House, in Kinloss, around 3 miles from Findhorn and 2.5 miles from Forres. She was a bright, engaging child and, from his letters, was clearly adored by her uncle Hugh.[1]

Grace married in October 1854 and moved to Glasgow with her husband, George McCall; but her happiness was cut short when he died 17 months later, followed very quickly by her infant son. She returned to Abbeyside and to her younger siblings but struggled to come to terms with her "crushing" loss.[2] Her uncle encouraged her to accompany him abroad,

1 Prestwich, Grace A. 1901: *Essays. Descriptive and Biographical.* With a memoir by her sister Louisa E. Milne. Edinburgh and London: William Blackwood & Sons, 3 and 5.
2 Op. cit. 8.

urging the advantages of foreign travel[3] and, in October 1858, she travelled with Hugh to France and Italy, on what was the beginning of a formative partnership. Grace collected fossils at several localities, drew museum specimens, and copied cross-sections for him, learning all the while.[4] It was on this first trip that she and Hugh saw the worked flints collected by Jacques Boucher de Perthes in Abbeville, in northern France, which included the Pleistocene Saint-Acheul material.

Falconer was so excited by these finds that he urged his friend, Joseph Prestwich, British businessman and geologist (1812–1896), to visit Abbeville as soon as possible.[5]

The discovery of worked flints alongside fossil elephant and rhinoceros remains in these French gravel deposits confirmed the antiquity of man. Both men had been involved in the excavation of a bone cave in Brixham in the south of England[6] earlier in 1858 and suspected that these flints and bones were contemporaneous but lacked direct evidence. Prestwich's subsequent paper for the Royal Society on the Abbeville deposits marked an important milestone in scientific understanding.[7] Although the relative age of the Pleistocene was well understood, the absolute age of the Saint-Acheul deposits would have been undetermined in the 19th century. Today it is determined as 424,000 BP, using marine isotopes.[8]

3 Ibid. See also the following "Letters to a niece", published in this anthology.
4 Op. cit. 16, 22.
5 Op. cit. 83.
6 Brixham Cavern, today also known as Windmill Hill Cave.
7 Prestwich, Joseph 1859-1860: On the occurrence of flint implements, associated with the remains of extinct mammalia, in undisturbed beds of a late geological period (Abstract). *Proceedings of the Royal Society of London*, 10, 50-59.
8 Antoine, P. et al. 2007: Pleistocene fluvial terraces from northern France (Seine, Yonne, Somme): synthesis, and new results from interglacial deposits. *Quaternary Science Reviews*, 26, 2701-2723. The archaeological and geological abbreviation BP refers to 'years Before the Present'.

The friends continued to meet and correspond on geological matters until Hugh's death in 1865. Grace would have been introduced to Joseph by her uncle and, in February 1870, the couple were married. At this time, Joseph was still working for the family wine business but, on retiring from the company in 1874, he was appointed Professor of Geology at the University of Oxford, a post he held until 1887. Grace took an active role in her husband's academic life, attending lectures, illustrating books and papers, as well as accompanying him on geological field trips. After his death in 1896, she edited his letters to critical acclaim.[9] But Grace, with her sharp intellect, also wrote herself, contributing geologically themed essays to periodicals, and producing two novels.

In 1897, Grace donated two hundred of her husband's fossils, including elephant teeth from the Ilford brick pits and from the historically and scientifically highly important site at Saint-Acheul, near Amiens in the Somme River valley, to the Falconer Museum in Forres. She also donated his letters, adding to the Falconer correspondence already held in the museum's collection.

Grace died at her beloved North Downs home, Darent-Hulme, on 31 August 1899, aged 66. Her commitment to the Falconer Museum was further demonstrated by two posthumous donations of £500 in 1899 and 1900, equivalent to nearly £137,000 today. Her passing was noted by the Geological Society, the President recording that only her female sex had precluded "the niece of Falconer, the wife of Prestwich" from being elected Fellow.[10]

Throughout her life Grace encouraged the education of women and she took an active part in the establishment of Oxford's Somerville Hall in 1879.[11] She had met esteemed

9 Prestwich, Grace A. 1899: *Life and Letters of Sir Joseph Prestwich*. Edinburgh and London: William Blackwood & Sons.
10 Proceedings. 1900: *Quarterly Journal of the Geological Society*, 56, lxi.
11 Prestwich, Grace A. 1899: *Life and Letters*, 305.

Grace Prestwich in 1876.
Photo from a pencil drawing by W. E. Miller, reproduced in: Prestwich, Grace A. 1901: Essays. Descriptive and Biographical. With a memoir by her sister Louisa E. Milne. Edinburgh and London: William Blackwood & Sons

mathematician and astronomer Mary Somerville (1780–1872) in Florence in May 1859 and again at Naples in early 1870.[12] On the later visit, Grace recorded that her husband and Mrs Sommerville discussed volcanoes, amongst other things, with Mary Somerville's intellect undimmed by her advancing years.[13] Women were allowed to sit examinations at Oxford from 1884 but did not receive the degrees that they had earned until 1920. Similarly, it was not until 1919 that the Geological Society admitted its first female fellows, twenty years after Grace's death.

Grace quotes extracts from letters between her uncle and her husband in her essays and in her biography of the latter, revealing their shared passion for geological discussion. Hugh brought his expertise as a palaeontologist to the debate about the age of man, whereas Joseph, as a talented amateur, contributed his wide stratigraphical knowledge to the controversy. The respect that each man clearly had for the other shines through in their writing, but it is the letters themselves that allow us to connect to these remarkable men and to the woman who documented the conversation.

A picture in a textbook can only give an impression; following the discussion of those pioneering and epoch-making scientists who actually handled the fossils that had been collected, brings the subject to life in a much more intense way. Scientific thought developed rapidly through the Victorian age, establishing frameworks that later discoveries have embellished but not fundamentally changed. The fact that the public is currently denied access to these objects, as is the case with the closure of the Falconer Museum,

12 Prestwich, Grace A. 1901: *Essays. Descriptive and Biographical.* With a memoir by her sister Louisa E. Milne. Edinburgh and London: William Blackwood & Sons, 31 and 132.
13 Prestwich, Grace A. 1899: *Life and Letters*, 224.

cuts us off from our forebears. It stifles intellectual curiosity and breaks the age-old chain of scientific discussion and academic endeavour.

About the author

Dr Alison Wright settled in Forres in 1998 and studied geology as a mature student at the University of Aberdeen. Having worked for the Open University and at the University of Glasgow, she now channels her enthusiasm for rocks through the Highland Geological Society and as a volunteer at Elgin Museum. She has become an ardent supporter of the Falconer Museum and is Treasurer of its group of Friends.

Letters to a niece

Hugh Falconer in his own words

Christiane H Friauf

One of the few easily accessible printed sources of information on Hugh Falconer, his life, and his thoughts, is this book containing essays, written by his niece Grace Milne, edited after Grace's death by her sister, Louisa E. Milne:

> *ESSAYS. Descriptive and Biographical, by Grace, Lady Prestwich, with a memoir by her sister Louisa E. Milne, published by William Blackwood and Sons, Edinburgh and London, 1901*[1]

Grace's essays, which are collected in this volume, originally appeared from 1879 to 1895 in various magazines, and her sister Louisa added a few unpublished papers. They contain travel reports, mostly of travels in the company of her uncle Hugh, and descriptions of Scottish scenery and history. While it is not a book on Hugh Falconer as such, we can gather a considerable number of clues from it.

1 The editor wishes to give thanks to BiblioLife, LLC, for undertaking to reprint often hard to find original publications that are in the public domain. The excerpts in this article are taken from their 2009 reprint of the *Essays*, with page numbers in accordance with the original.

Louisa gathered valuable information in her memoir of Grace which precedes the essays. When Grace Milne was still Hugh Falconer's young niece and not yet the author and geologist Lady Prestwich, she kept in touch with her travelling uncle through numerous letters. Louisa copied the text of various of Hugh Falconer's letters to Grace and integrated them into her memoir. In our attempt to shed light onto a still amazingly little-known scientist who helped shape the era of Darwin, we are sincerely indebted to the Milne sisters. Unfortunately, at the time of writing (2022), we don't have access to the Falconer correspondence itself held in the Falconer Museum's collection, hence the indirect way of quoting from a book.

Here are several excerpts from Louisa Milne's memoir of Grace. Their aim is to let the eminent scientist, imaginative explorer and last, but not least caring uncle Hugh Falconer come to life, with the help of his own words.

Botanic Gardens, Calcutta,
19th January 1854

My dear Grace,

I wrote to you very hurriedly last mail, and fear that some of my remarks may have startled you. I wish therefore to make my meaning more clear.

When you are asked to attend a **lecture** *on any scientific subject you go for an exercise of reason. It has never yet been pretended that there has been a divine revelation expounding the knowledge of the natural world. The Almighty has given us reason, and left us, by the adequate exercise of that power, to investigate the laws and order of creation. Take astronomy, and see what has been done in it. Is there any educated person now living that believes 'that the sun was made to rule by day, and the moon by night,' as servile attendants on the earth? No—not one.*

Does any one now believe that the sun rolls round the earth? No: yet in former times the universal belief of mankind at the present day was denounced as a heresy opposed to the Bible. Geology is now passing through, or rather it has passed, the ordeal that astronomy did in the days of Galileo. When the ignorant and bigoted fail in reason and argument, they raise the yell of intolerance and charge the doctrine with **infidelity**. The odium of the term serves their end for a time, and what follows? This denounced infidel doctrine, after the lapse of a few years, becomes the accepted faith of all mankind, philosophical and religious. When, therefore, in a good cause, the imputation of **infidelity** is raised, one need not be ashamed of it. There can be no two truths in nature opposed to each other. As regards that creation of the world, the evidence is as clear that millions and millions of years must have elapsed between the first appearance of life on the earth and the present day, as that you and I possess eyes and ears and have a living existence. The difference merely is, that the evidence is not of the same nature. The one is complete, the other fragmentary, but equally significant and strong. For instance, a tooth or the end of a joint, found in a rock, is as conclusive evidence of the former existence of an animal as if all the structure—skin, flesh and blood, and living limbs—were before us. The only difference is that in the one case the evidence is **cumulative** and complete in every detail, while in the other it is fragmentary and inductive, but equally clear and conclusive in both. For the Almighty has so ordained it that reason can safely reproduce all that has been lost, and restore to the tooth all that was correlative to in in life. But mind you, that what I have said here bears solely upon our knowledge of the physical world, and not upon doctrines of faith for our moral and religious guidance. But I must not preach too long on this head... Make offer of my love to all at Abbeyside, and believe me, my dear Grace, your ever affectionate uncle,

H. Falconer.[2]

2 Prestwich, Grace A. 1901: *Essays. Descriptive and Biographical*. With a memoir by her sister Louisa E. Milne. Edinburgh and London: William Blackwood & Sons, 5-7.

The above letter was written at the beginning of 1854, prior to Grace's wedding to George McCall later this same year. Soon afterwards, in 1856, she lost her husband and her infant son. As Alison Wright points out in her essay "Connecting with our geological past", Grace struggled to come to terms with the loss.

This is the background of Hugh Falconer's various letters to his niece in 1858. In the following excerpt from one of these letters we get a glimpse of his distinct sense of humour. He also shows respect for Grace' Christian belief, while he lovingly tries to win her back to life.

… Not to wed you to frivolous enjoyments of life, but to enable you to judge for yourself. Till you had done so, I could not look upon you in another light than a demure little Puritan, whose strength lay in the ignorance of her own limited experience. … There's a home compliment for you. … I shall not be pleased certainly if you push the privilege too far, and turn nun and take the veil. But you may eschew all the vanities of life, turn Sister of Mercy, and attend the hospitals under Miss Nightingale's banner. But I must bargain for one thing. There must be no parade about it. … It must be the religion of the heart and not of external formalities doing good works for the sake of good in your day and generation, and not talking demurely about a future state! … With the mere formalistic profession of religious creed I have no sympathy. From the incessant contact I have had through life with every conceivable form of human belief—Pagan, Mohammedan, and Christian—I have learnt the virtue of toleration. … The anchor of my faith in the truths of Christianity has no concern with the embittered interpretation of abstract dogmas among different creeds as a means of salvation, but upon the purity of the Christian faith, and upon the doctrines of the meek and lowly Jesus as a rule of conduct in life. I consign no man to eternal perdition because the reason with which the Almighty has endowed him leads him to think differently upon some abstract dogmas from myself, nor do I heed much the denunciation by him which would consign me to the same lot.[3]

3 Op. cit. 8 f.

Louisa states: "At last Dr Falconer took his niece away from the sad associations at home on a prolonged tour abroad, and an amusing letter gives the details of the proposed journey through France and Italy".[4]

<div style="text-align: right;">31 Sackville Street, W.,
25th Sept. 1858.</div>

My dear Grace,

I am loath to the last degree to leave England at present, as I have so much unfinished work on hand; but I have already had a reminder that the least check or cold will lay me up for the winter. I do not like the idea of travelling alone, and it has occurred to my obtuse head that if you would accompany me it might be a pleasant arrangement for us both. The Deductive Mind will at once leap to the just perception of the case ... The Inductive is now growing old and stupid, and requires some one to watch over his declining years; the Deductive Mind is young, lively, and discreet. The Inductive is an old and experienced traveller, who has seen many lands, observed a little and read a little; the Deductive has an excellent turn for rational observation, and would not be too proud to have a guide in visiting the classic ground of ancient history. ... The Deductive Mind must agree to the following arrangements. ... Only two gowns: when the old wears out buy a new one. No band-boxes!

Write, like a good girl, and say Yes. Arrange to come up with Uncles Charles. ... I ought to have given you earlier warning, but I have been undecided about going myself. Show this to Uncle Charles.

My dear Grace, your affectionate uncle,

<div style="text-align: right;">H. Falconer.[5]</div>

4 Op. cit. 11.
5 Op. cit. 11 f.

Louisa concludes: "The travellers left England towards the end of October and journeyed in a leisurely fashion southwards, stopping for some time at Abbeville, Paris, Lyons, Avignon, Nîmes, Montpellier, and Marseilles. Dr Falconer visited the museums everywhere along their route, examining and comparing fossils (for the most part the bones and teeth of Mammalia), which Grace was often occupied in figuring for him."[6]

About the editor

Christiane H Friauf is a historian, non-fiction author, and editor. In a previous life in Germany, she published numerous books and articles, including on culture history, visual art, and literature. Since her recent relocation to northeast Scotland, the cultural as well as the physical landscape of this special part of the world draw all her attention.

6 Op. cit. 12 f.

Bewilderment in managing pivotal Victorian research

Dr John Grant Malcolmson, pioneer of early Scottish geology

Bob Davidson MBE FGS

In Castlehill Church on the High Street in Forres is a plaque dedicated to the memory of Forres born Dr John Grant Malcolmson M.D., F.R.S., F.R.A.S., F.G.S. (1802–1844) which was erected by his brother, James Malcolmson. John Malcolmson's portrait has also been chosen, with those of other scientists, to embellish the façade of the Falconer Museum.

During his short lifetime, John Malcolmson was showered with accolades for his medical work in India and particularly for his geological achievements at home in Moray which were ground-breaking at the time. Malcolmson might have retired in his home town Forres but he died in India.

Rather than trying to be a science chronicle, this essay focusses on the people in the story including the impressive clutch of Malcolmson's fellows. Hugh Falconer was a contemporary of Malcolmson's, as was the esteemed Rev. Dr

George Gordon of Birnie, all of whom attended the University of Edinburgh as well as sharing their link with Moray.

Malcolmson achieved great reputation for his exceptional intellect, but also for his great humility, coupled with a huge zeal for fieldwork. He worked very much as a leader in his geological field, ploughed his own furrow and in doing so laid the foundation for subsequent scholars right up to the present day. He was lauded by many as a pioneer in the stratigraphy of the Old Red Sandstone of Moray. However, it appears that some may have been so dazzled by his reputation that misjudgements were made when referring to his writings and particularly to his geological cross sections of the Old Red Sandstone of Moray district.

His name will forever be intertwined with a Devonian fossil fish locality (380 million years old) near Auldearn in Nairnshire. The celebrated Middle Devonian fish bearing nodule locality named Lethen Bar, 8.6 km southeast of Nairn, has an almost apocryphal reputation in vertebrate palaeontology due to it being the source of fossil fishes, beautifully preserved inside limestone concretions, in white, crimson, and purple bone, of which specimens can be seen in Elgin Museum today.

The fact that the quarries have been deemed unlocatable for almost 140 years has, no doubt, enhanced the locality's legendary status. The quarries were originally dug for limestone. Limestone was needed in the manufacture of quicklime and later of calcium hydroxide which was used on the land and in building mortar. The area had been quarried for limestone nodules for more than 10 years when Malcolmson and his friend William Stables arrived in 1839 and found beautifully preserved fossil fishes inside some of the nodules at Lethen Bar, during Malcolmson's relatively short geological survey of the district.

Dr John Grant Malcolmson, photo of an engraving in the Falconer Museum, Forres

Martin's 1837 geological sketch map

Prior to Malcolmson visiting the area, local schoolmaster, John Martin produced the first ever geological sketch map of Moray in 1837 in his prize winning 'Essay on the Geology of Morayshire'. All the quarries known at the time are marked

with varying degrees of accuracy utilizing a circle and dot symbol. Martin also used a dash symbol to mark other key places. His map was hailed at the time as the best available so far. Despite its significance and important content, it was later largely overlooked and even dismissed by a researcher as "extremely inaccurate". Its most important feature is that it is the first record of Lethen Bar Quarry. Elgin Museum highlighted its importance in an exhibition in 2021. Martin and Malcolmson became firm friends, and we can assume that Martin's map influenced Malcolmson's work.

Leading protagonists

As this is a story about people, we will now introduce the most colourful of our characters. Lady Eliza Maria Gordon-Cumming of Altyre House (*c.* 1798–1842) was an aristocrat and mother of thirteen children who whiled away the days with her horses and water colours, at which she appeared to be uniquely talented. She probably met Malcolmson sometime in the period of his discovery of the fossil fishes and became so entranced by them that she built a very large collection, at times having the quarry work exclusively for her assemblage, which is now known as the Altyre Collection and resides in the National Museum of Scotland.

Lethen Bar had by then risen to its celebrated status and in 1839 Malcolmson, while keen to return to India, had reluctantly lodged a manuscript containing a description and sketches of its geology with the Geological Society of London (GSL). It was Hugh Falconer who assessed this memoir for the Geological Society and indeed the notes on the Rev. Dr George Gordon's copy of Malcolmson's report are written by him. Gordon (1801–1893) became Minister of Birnie in 1832 and was a prominent member of the scientific community, accompanying Malcolmson on his field work in 1838 and 1839.

Malcolmson, as he had intended, finally departed for India in 1840, where he passed away in 1844, aged just 41. This could be the end of the story but instead it sets in motion a new turn in what was to become a rigmarole, with Malcolmson's manuscript having consequences for future generations of researchers.

A Saga of loss and rediscovery

After his departure for India, Malcolmson's manuscript became forgotten in the archives of the GSL and was only rediscovered 20 years later. The following is a chronology of the bewildering events that led to the decisions for its publication in three separate versions by the GSL, and a later publication in 1921, all of which were to the detriment of Malcolmson's original work.

1. Malcolmson's 1839 manuscript lodged with the GSL that year then overlooked for twenty years, a copy of which is now held by National Museums of Scotland.
2. Malcolmson's 1842 abstract (from the manuscript of his 1839 memoir) published by the GSL.
3. A memoir submitted by the Rev. Dr George Gordon is published in 1859 with paraphrases and quotes of large parts of Malcolmson's original manuscript, of which Gordon had a copy, with some editing but without illustrations. The interpolations on the text of Gordon's copy are in Hugh Falconer's handwriting.
4. In 1859 Malcolmson's memoir published but only with those remnants of the text that had not been published by Gordon, plus editorial notes and only one of four illustrations originally lodged (Plate XI Geological Sections).
5. In 1921 the Inverness Scientific Society re-publishes Malcolmson's almost complete, and apparently not

proofread, memoir, under the wrong author's name of A G Malcolmson. This version was not accompanied by Plate XI although it makes direct reference to it, and it contains several errors which caused Dr Mahala Andrews to doubt the provenance of its content. Regardless of Andrews' reservations, an editorial note in *Pioneers of Science in the North*, by Thomas Wallace FGS, published in 1921, again by the Inverness Scientific Society, confirmed that Wallace had presented a copy of Malcolmson's (presumably incomplete) manuscript to the organisation in 1915 which is published in this 1921 volume. Wallace states that he has the manuscript 'by permission of George Gordon', suggesting that this document may originally have belonged to Gordon.

Understandably, this apparently illogical dealing with Malcolmson's work caused difficulties for geological and historical scholars from this point onwards.

Malcolmson's idiosyncrasies

Malcolmson cannot have spent much time in Moray where he was only from 1838 to 1839, with travels outside of the area as well. He must have crammed in a lot of work in the field, discovering several new fossil fish localities in what would have been only months, not years, while simultaneously drafting his manuscript. It must also be appreciated that he was in ill health which could have added to his stress. His reluctant and hurried deposit of the manuscript with the GSL and his departure to India and untimely death four years later meant that he had no say in how it was published. Obviously, he had no chance to read a proof or enter into discussions over his findings.

Malcolmson was of his time. He operated as a free agent in his geological pursuits, and this becomes apparent in

examining his piecemeal published memoir. The only version to contain the important geological sections is the very brief 1859 memoir published from remnants under his own name. Although his methods presented inconsistencies, one of these sections has implications for later field workers.

At first glance, the section of Lethen Bar is an almost impossible section in that "Cairn Bar Hill" is wrongly named, the hill feature labelled "Lethen Bar" with the nodule bed at its base does not exist and the topography at "Lethen" is greatly exaggerated as are the angles of dip and slope in general. But are these errors or was Malcolmson using devices to highlight key information and avoid confusion? Unfortunately, he did not qualify or otherwise explain his reasoning or mode of presentation.

In 1839 there were two adjacent landmarks which shared the same name, "Lethen Bar Hill" and 900 metres to the northwest, "Lethen Bar Farm" upon which the nodule bed lay. The name "Cairn Bar" appeared to be rarely used and was sometimes given to an adjoining hill to the east. Perhaps in a bid to avoid confusion of the two place names, Malcolmson may have extended the area of Cairn Bar to include Lethen Bar Hill. The small hill with the nodule bed approximates the position of Lethen Bar Farm which is a flat gently sloping meadow. The fish bed lies just under the surface of the flat meadowland in a trough in the underlying rocks which Malcolmson did not know. Instead, he may have decided to accentuate the relief in the area so that he could draw the fish bed as a continuous layer.

Other quirks include the omission of a 600 metre expanse of the rock he called gneiss between the summit of Cairn Bar Hill and the Lethen Bar nodule bed feature. This can be explained as he trusted the Geological Map by John MacCulloch whom he admired. This map had a significant error in that the granite shown on Malcolmson's section was positioned too far north, obliterating the gneiss bedrock. It

would have directly produced the situation on Malcolmson's section. The dip and corresponding slope in the area is only five degrees and may have been difficult to represent, as the total distance of the section is 11.75km. Reference to other contemporary geologists' sections suggest that in order to illustrate dipping formations, some accentuation was employed.

Of course, Malcolmson may have simply made mistakes due to his whirlwind schedule and health issues. But in taking Malcolmson's work at face value, later workers appeared to misinterpret what he meant, leading to their own misjudgements.

The British Geological Survey

Enter Dr John Horne (1848–1928), who worked for the British Geological Survey (BGS) and was charged with surveying the area including Nairnshire in 1878, with his eminent party of geologists, including H. Cadell, C. Crampton, R. Carruthers, J. Linn, and Horne's companion, Ben Peach. John Horne was a rising star in the BGS and widely recognised as an astute field worker by his peers. Today Peach and Horne are still revered to the extent that statues have been erected to both at the side of the A835 at Knockan Crag, Ullapool.

On several occasions Horne lavished praise on the work and sections of Malcolmson's writing, stating that he had "thoroughly grasped the geological structure of the Old Red Sandstone track to the south of the Moray Firth". Note the hint of awe in this statement.

Horne claimed to have built in his own research on Malcolmson's work and his knowledge of the literature and expertise as a geologist may simply have enabled him to correctly interpret Malcolmson's memoir and sections in the context of their time, without further comment.

Be that as it may, in omitting to explain his interpretation of Malcolmson's work it appears he left the way open for future workers to wrestle with the apparent inconsistencies.

Efforts to rediscover the fish bed

Since Horne's time, several workers have set out to rediscover the fish beds of the Lethen area, either without success or without publishing any findings, with one notable exception.

Dr Sheila Mahala Andrews (1939–1997), known as Mahala, obtained her PhD on fossil fishes, particularly the group from which land vertebrates would evolve, at Cambridge and was appointed a senior scientific officer at the Royal Scottish Museum, now National Museums Scotland (NMS). Andrews published unparalleled work on the discovery of fossil fishes in Scotland in 1982 and 1983 and drew heavily on the work of Malcolmson and, to a lesser extent, Horne. Her attempts to confirm the past locations and mode of exposure of the workings of the Lethen Bar quarries were not particularly successful partly due to the piecemeal publication of Malcolmson's work which she, like Horne, appeared to admire. She did however forego important lines of evidence by dismissing or setting aside some work by previous workers, especially John Martin's map.

More importantly, while preparing her 1983 paper Andrews performed detailed and extensive research in unpublished correspondence, archives, and original manuscripts which will prove invaluable into the future. She cited Malcolmson's work literally, specifically the original manuscript, but interestingly not the aforementioned section of Lethen Bar. However, she faithfully reproduced its detail at face value erroneously declaring that "Lethen Bar is a low hill over a large area with a continuous outcrop of a fish bed around its base", clearly lifted directly from Malcolmson's section without challenge.

She also published a theory, based entirely on Malcolmson's garbled claim that a line of projection of the fish bed from the NW would "strike the hill of Cairn Bar near a newly opened quarry on the farm of Lethen Bar" thereby deducing, unconvincingly, that the quarry was constantly on the move over an area 2km by 1km, and "Lethen Bar" was simply the name given to where the quarry was at a given time. She even created a hypothetical quarry to support her tangential theory in her map which, interestingly only features static quarries identified by Horne back in 1878.

Her unswerving acceptance at face value of crucial passages in Malcolmson's paper and thereby her wayward interpretations effectively installed renewed kudos in Malcolmson's potentially misleading paper and set the direction in which her successors would follow.

The Inexorable Stan Wood

The next to take up the baton to rediscover the fish bed, in 2001, was renowned Edinburgh fossil hunter and dealer Stan Wood (1939–2012). Wood was a character in every sense of the word and made many discoveries which earned him worldwide acclaim. He was particularly famous for his discovery, near Bathgate, of a fossil which he named Lizzie the Lizard, believed at the time to be the earliest reptile. The scientific furore surrounding its potential fate of being lost to a foreign museum, who were offering to pay top dollar, was silenced by an appeal for public donation resulting in it being saved for Scotland with a total sum of £130,000 being raised. It is now in the NMS.

According to a sketch map and sections in the BGS archives, Wood, armed with Andrews' 1983 paper and thereby Malcolmson's memoir, but also Horne's 1923 map and memoir, invested considerable resources in 2001 on heavy excavation and earth moving equipment and excavated four test pits adjacent

to Malcolmson's line of section, appearing also to have targeted Andrews' hypothetical quarry, but unfortunately the fish bed was absent in all four pits. Since Wood's exploits, occasional focus went on the unsuccessful quest for any remaining potentially productive deposits that might yield the very best-preserved fossil fishes. One of the main issues has been that since Andrews' and Wood's time no more evidence has come to light and nothing more has been published about the provenance of the Lethen Bar quarries and their elusive fossil fishes.

Conclusion

The story of Malcolmson, Lady Cumming, and Lethen Bar has acquired apocryphal status in palaeontological and historical realms due to the quarries being a source of beautifully preserved fossil fishes and the notion that they somehow became lost. This was never the case as the BGS had retained in their public archives the mapped localities of at least four quarries since 1878. The confusion commenced when a decimated version of Malcolmson's memoir was published fifteen years after his death, in two disparate journals in 1859, and in an almost complete form but containing significant errors and omissions in 1921, a series of mishandling that would not happen today.

Malcolmson and his stratigraphical mapping methods were of their time and had to be taken in context, which John Horne, the Victorian geologist, appeared to understand and interpret accordingly, while 20th century palaeontologist Mahala Andrews may not have appreciated this, taking his note on his geological work on the fish bed at Lethen Bar at face value.

Both approaches reflect the utmost respect for Malcolmson's work, while both lack the rigour of challenge and verification which is at the heart of debate in research.

Had Horne expressed the inconsistences that he reinterpreted in Malcolmson's geological sections, Andrews may well have presented her own interpretations and arrived at more logical conclusions, perhaps to the benefit of Stan Wood and others who followed her.

Finally, from 1987 to 2010 the BGS resurveyed the area, producing a greatly updated geological map compared to the 1923 edition surveyed in 1877 and 1878. This has enabled the present author and colleagues to complete a project of reconciliation of Lethen Bar's past and present evidence based on our new findings from 2005 to the present. An overhaul of the literature, in concert with detailed site surveying, which we intend, will bring the various mysteries to a close.

Acknowledgements

I wish to thank Robert Hoskin (Lethen Estate) for access permission. I am grateful to Alison Wright (Elgin Museum), and Gavin Berkenheger for valuable discussion, and to the family of the late Professor Nigel Trewin for access to documents from his estate.

Literature

Andrews, S.M. 1982: The discovery of fossil fishes in Scotland up to 1845. *Royal Scottish Museum Studies*, Edinburgh.

Andrews, S.M. 1983: Altyre and Lethen Bar, two Middle Old Red Sandstone localities? *Scottish Journal of Geology*, **19** (2).

Collie, M., and Bennett, S. 1996: *George Gordon: An Annotated Catalogue of His Scientific Correspondence*. Abingdon: Routledge.

Collie, M., and Diemer, J. 1995: *Murchison in Moray: A Geologist on Home Ground, with the Correspondence of Roderick Impey Murchison and the Rev. Dr George Gordon of Birnie*. Transactions of the American Philosophical Society, Philadelphia.

Davidson, R. G., Trewin, N.H., Armstrong, J., and Waters, S.R. (in preparation): Dr John Grant Malcolmson and a reconciliation of the Middle Devonian Lethen Bar and Lethen House fish bearing nodule localities. With notes on the Devonian nodule beds of the southern Moray Firth area. *Scottish Journal of Geology*.

Duff, P. 1842: *Sketch of the geology of Moray*. London.

Elgin Museum 2020: News about the exhibition 'At the water's edge', https://elginmuseum.org.uk/year-of-coasts-and-waters-2020/, viewed 17 July 2022.

Gordon-Cumming, C.F. 1904: *Memories*. Edinburgh and London: William Blackwood & Sons.

Horne, J. et al. 1923: The geology of the lower Findhorn and lower Strath Nairn including part of the Black Isle near Fortrose. *Memoirs of the Geological Survey, Scotland*, **84** and part **94.**

Malcolmson J. G. 1859. On the Relations of the different parts of the Old Red Sandstone in which Organic Remains have recently been discovered, in the Counties of Moray, Nairn, Banff, and Inverness. *Quarterly Journal of the Geological Society*, **15**, 336-352.

Malcolmson A. G. (J. G.) 1921: On the relations of the different parts of the Old Red Sandstone, in which organic remains have recently been discovered, in the counties of Moray, Nairn,

Banff and Inverness. *Transactions of the Inverness Scientific Society and Field Club*, **8**, (1912–1918), 441-464.

Miller, H. 1997 (orig. 1858): *The Cruise of the Betsey*, with *Rambles of a Geologist*. Facsimile reprint with introduction and notes by M.A. Taylor. Edinburgh: NMSE - Publishing Ltd.

Orr, M 2020: Collecting women in geology: opening the international case of a Scottish 'cabinétière', Eliza Gordon Cumming (c. 1798–1842). In Burek, C.V., and Higgs, B.M. (eds): *Celebrating 100 Years of Female Fellowship of the Geological Society: Discovering Forgotten Histories*. Geological Society Special Publications, **506**, 1-11. London: Geological Society of London. https://doi.org/10.1144/SP506-2019-205

Wallace, T. 1921: Pioneers of Field Science in the North. Dr John Grant Malcolmson. *Transactions of the Inverness Scientific Society and Field Club*, **8**, (1912–1918), 419-423.

About the author

Bob Davidson MBE is a freelance oil and gas well engineer who has been collaborating in research on Scotland's Devonian fossil fishes for more than thirty years. He is co-author of numerous research papers, Honorary Research Fellow at Aberdeen University, Department of Geoscience, and was elected a Fellow of the Geological Society in 2019. Currently he chairs the Friends of Hugh Miller based in Cromarty.

IMAGINATION AND SCIENCE

A view from a tea garden

Jude Clay

The view from the garden where I grew up is the same view my ancestors grew with for over 180 years. Lush green steps sliced into the mountains, each slope turning into blue and deepening as the distance takes them into the sky. It is a place of drenching rains and meditative bells, of sun breaking through mists, and snows in winter that cover us all and kill many. Before we came here, our family lived in quite a different landscape. We were brought here by a group of men who were strangers to this land like we were. One of them came here to study the mountain soil and the plants that already grew on the slopes, and he wrote a recommendation. He said this would be a rich and prosperous place for us. His name was Dr Hugh Falconer.

Dr Falconer loved everything that lived in the soil, whether it was seeds and plants, or fossils and bones, and signs of ancient life. He came to my Himalayas in India to nurture a garden. Not like our garden; his first one had hundreds of different plants, some kept under glass, some exotic and unusual. He was good at it; and when the British realised how valuable my family were, they asked him to see if he could start a garden like ours here on these mountainsides. Some

people saw the thin soils and steep slopes and felt the scorching sun and freezing snows and looked at the immense distance to the sea and said, "no, it can't be done". But Falconer saw all these things and thought of our sisters in the mountains of China. He said, "give me some plants and I will grow you a garden worthy of China."

So, they sent out a man of secrets and daring, a man of Fortune, and he stole my ancestors from China and smuggled them out to sea and to the shores of India. Many of them died on the journey, weakened without the soil of their home and by the salt in the air, but some survived. They were sailed upriver, between wide banks of lights and sound and smoke and children and buildings.

Falconer met them, at the river's edge, and took them long, long over-land to their new gardens in the mountains. He toiled and nurtured and taught others how to care for us too; and soon we began to flourish, grown from the hardiest stock. My ancestors uncurled new leaves to the sun and grew stems up to meet it. Meanwhile, Fortune and Falconer and the people they worked with were learning how to pick only the young flush of our leaves, how to steam and roll and shape and oxidise, how to dry us out so we have the perfect colour, the perfect taste.

There was a new journey to be made – to London – one on which my ancestors travelled with Falconer himself. They were rocked on salty swells and buffeted by sea-winds and, eventually, arrived at the foggy, grey port full of shouts and movement and industry. A man who knew about teas, W.J. Thompson, threw the leaves into boiling hot water to brew and declared them a fine example of the work we plants could do if we put our minds to it. As fine, even, as those of us grown in our homeland, China. This was just what Falconer had been hoping for: our garden was a success.

But our friend Falconer could not come back to our gardens. He was wilting and needed nurturing in good soil

before he could continue his work elsewhere. Our garden was passed to others, his recommendations and research used and expanded. The tea gardens of India spread and flourished, and the people learned how to bring out the best in us.

Now it is my turn, I am in flush and will be plucked from the mountains. I am spread out among my sisters and our young leaves curl. Once the colour of emeralds, our leaves become soft and deep, the green of the sea. Now, I am pressed tightly to my sisters and rolled, we form one lump, as tight as family. We are of a fine quality, the first flush, so we do not need to be left to ferment long. The most skilled and experienced humans work with us now, and they know that when the air is filled with the scent of apples, we have gathered the right strength and are ready. Next, I must be dried. I am almost perfect. If I am not dried now, I will spoil.

Once dried, the sorting shakes me loose from my sisters of different sizes, different grades, and we are packed and placed in crates. I am going to England. I am following in the footsteps of Falconer himself. The sea sways and swells and we are rocked in our container, but we, at last, reach the cold, damp air of England and are loaded onto lorries. We scatter the country, travelling this way and that to make sure no corner is neglected.

Until, until, that glorious day. We are spooned, or plopped into a cup or teapot, we are steeped and brewed, and strained and sipped.

There is a man in a high-vis jacket by the side of the road and he drinks from a flask, there are two sisters catching up after a time away. Friends gossip over us, and mothers brew us to give comfort. Workers need us to get through the shift, or the day, and some people sit alone and quiet and breathe our fragrant steam and feel the way we work into the brain and heal human woes.

We are drunk fast and scalding, or slow and replenishing, or forgotten until we are cold and glugged hastily on

rediscovery. Biscuits are dipped and undipped, sugars stirred, even milks made of oats and nuts and beans. There are even some who swill us round and round and gaze into the constellations we create on porcelain, hoping to see the future. We understand that. We can feel the future in us, the seeds, the saplings, the new flushes. And the past, the mountains of China and India, hundreds of years of growth, the fingers of the workers, the Fortunes and Falconers, the ink on the pages and the chests on the ships. And the hundreds and thousands of us that live at present, growing and travelling and steeping and keeping the world moving.

About the author

Jude Clay has dreamed of being a writer since she adapted Little Red Riding Hood in favour of the wolf when she was six. Now, she writes fiction and essays inspired by nature and you can find her mailing list and blog on her website www.jeclay.co.uk or follow her on Instagram @j.e.clay – She likes her tea loose: two thirds Yorkshire, one third Earl Grey.

The tortoise and the elephant

Jenny Mena

Fairytales and fables have fed our imaginations throughout the ages. The idols and myths we have grown up with remain and are shared with our young ones. Most of these stories are quite familiar, and their stories tend to be known everywhere. But what of the rare and more mysterious, or even the untold stories of the characters that appear out of nowhere, almost with no explanation? There is one such character, whose story has never been told. A "creature" of sorts with an odd appearance, and some most unusual props. This character is... the Tortiphant!

Who is this character, you ask? A sculpture which claims to be in likeness of the great Hugh Falconer, or at least a representation of various aspects of his life. The Tortiphant is an elephant, riding a tortoise, drinking a beer, wearing spectacles and the world atop of his head. Such a peculiar type, and quite the sight to see. Little is known of this figure, other than a few mentions of it being a sketch drawn into life by some dear friend of the late and great Mr Falconer. That is...

... until today.

Ladies and Gentlemen, I would like to share with you the real story of how the Tortiphant came to be... as told to me by the "Crickespies", a mass brigade of spy crickets, who saw everything first hand.

This tale begins so long ago, between the time when the dinosaurs perished, and before humans came to rule...

The land belonged to the animals, of sizes big and small. Some that flew, and some that grew a little, and some grew very tall. At this time the world was changing, looking different every day. The land became unfit, forcing the animals to go away. In this world there was a tortoise who was greedy, selfish, and cared nothing for the needy. He preached and sang about knowing the way, to the place where all the animals could stay. Where food and water were abundant and more than enough to share. He promised all the animals, for a price he could show them where. When the animals had given all the money they had, the tortoise did something really bad. He gathered all the animals and gave to them the map. Then sent them all away, and upon his riches, took a nap. What the animals did not know, about where the tortoise told them to go, was that the place which promised a feast, existed in the west, not in the east. The tortoise sent them all to the east, but west is where he'd go, to never share anything with even the smallest beast.

Not all of the animals followed the group, a lone elephant was too busy making soup. When the elephant had it finally done, there was no one left – he was the only one. Saddened by what he had seen, he sat upon a stump to read. He settled under the bright blue sky, a beer in hand, glasses for his eyes. There he read until night fell, then settled into bed, not feeling well.

The Gods had seen what the tortoise had done, and they punished him in more ways than one.

"You should not have done what you have done!!! Your journey to the west shall be no fun. For the weight of the world you shall carry on your shell, until a lesson you learn very well!"

And so with the world upon his back he went, but within two feet he was spent. The world just shifted and rolled down the sides. It wouldn't stay put no matter how hard he tried. But just ahead, what was this? An elephant! Too big to miss. The tortoise smiled a nasty grin. An idea had he, more evil than sin. Up to the elephant he goes, then taps his trunk with the tip of his nose.

"Dear elephant, I can make you rich, if you could help me in a pinch. I need to go out to the west, but to carry something, I think you'd be best. If you could take me and this world upon your back, I promise you all the gold in a stack."

The elephant remembered his long-lost group.

"I shall take you after I finish eating my soup."

Then off they went, as elephant carried the weight, while tortoise laughed that he took the bait. For days and weeks they crossed the land. Still nothing more in sight than sand. What was it that the tortoise had planned? Never would he pay elephant of the riches so grand.

On the morning of day ninety-seven, there appeared a site of beauty. Elephant asked,

"Is that heaven?"

Just ahead, could it be trees? Everywhere, as far as their eyes could see. They ran into the grassy fields, the bushes blocking the sun like shields. Waterfalls and berry trees, at the river they fell to their knees. They drank until they could no more and then fell asleep on the grassy floor. When elephant woke up, it was already dark. But nowhere was tortoise, not a single mark. Elephant cared not that he had left, for food was plenty and his mouth was wet.

Suddenly the skies opened wide, and elephant looked everywhere for a place to hide. Then a figure fell from the sky, it was tortoise! Falling from way up high.

"Again, you deceived another with your tricks. You should receive a million licks. But your shell would not allow it so, so a better punishment you will know. You shall know the burden of your weight and carry on you tenfold the rate. Forever you shall walk your path. With the world *and* the elephant on your back. Where he can rest, and he can read, and have plenty of beer to fill his need. And you, tortoise, cannot keep your name, as it puts the other tortoises to shame. From now on those who see you will chant

'Look, there goes the Tortiphant!'"

And so this is the story, or so I'm told. Be sure to tell others, before you get old. Now that the tale of the Tortiphant is brought to light, I bid you farewell, ado and goodnight.

About the author

Jenny Mena began as a creative writer of mostly poetry. She has now expanded into any genre she can by entering contests and competitions ordinarily out of her comfort zone. While writing is something she both enjoys and cherishes, her heart is filled by the love of two wonderful guys in her life: her son who never lets a day go by without a huge hug, and her partner of 16 years who has braved a very harsh world by her side. You can read more about her on her website https://jennymena.wixsite.com/mywords

Elephant's head

Luca Brite

The ground is squishy beneath my hiking boots that sink just slightly with each step. The boggy sub-alpine meadows underneath the volcano are alive with color, monkey flowers pink and yellow and pale creamy louseworts. Finally, I find my favorite lousewort, Elephant's head with columns of bright pink to purple flowers. The upper hood first curves downward and then swings outward like the trunk of an elephant. The lower lip spreads out wide like flapping ear lobes. My index finger trails along the outline of the Elephant's head flowers wishing that I could pet an elephant.

Orobanchaceae, the broomrapes, is now the family name for Elephant's head. At one time the Elephant's head belonged to *Scrophulariaceae*, the figwort family. I can't keep up with all the name changes and the drama of having to be precise about taxonomy, the branch of science that deals with naming, defining, and classifying groups of biological organisms. For me, it's enough to celebrate the beauty and biodiversity of the subalpine North Cascades that is covered in snow nine to ten months a year.

Ambling along, I wonder how this land was shaped not just by the weather and the volcanos but also by the animals, the plants, and by the first humans to walk this ground.

Although the Nooksack Indians did not live at this elevation, they hiked in the high country in search of blueberries and mountain goat. They dried the berries for winter, and they gathered mountain goat hair to line their blankets.

Like Hugh Falconer did in his early years as a biologist and a doctor, I love to study how people of a particular region used plants for shelter, food, clothing, and medicine. Meanwhile, my youngest son, at eight years old, searches for fossils in the creek behind our house at 900 feet in elevation, just like Falconer searched for fossils in India and Europe. My son hopes to find the fossil of an ancient mammal, a dinosaur, or a bird. So far, his dad and he have only found clam fossils and the segmented fossil of a snake or a worm, some palm tree fronds, fern leaves, and leaves from an ancient oak tree. This love of discovery keeps him searching day after day.

"What do you know about Falconer, the palaeontologist?" I ask him.

He looks at me in confusion until I ask him what he knows about the Columbian Mammoth, *Mammuthus columbi*.

"The Columbian Mammoth lived all over the US," he says to me as he looks up from his drawing. "I'll get my books to show you."

While he flips the pages searching for pictures, I tell him that Falconer first named and described the Columbian Mammoth in 1857, after his colleague Charles Lyell had sent him the molar fragments from the excavation of the Brunswick-Altamaha Canal of Georgia in 1846. Falconer named the elephant-like animal *Elephas columbi*. Since then, like the family name of Elephant's head changing from *Scrophulariaceae* to *Orobanchaceae*, the taxonomy, in constant turmoil, as it seems, has changed to *Mammuthus columbi*.

"Falconer named the mammoth after Columbus, and I wonder if he would again?"

He hears that tone in my voice that means I'm annoyed at some injustice in the world and asks, "What do you mean,

Mama? Why are you mad at Columbus?" He brings his book over to show me pictures of mammoth fossils.

"Columbus enslaved the native people in the lands he 'discovered'. But how can you discover something if people have already been there for centuries? It means that you believe those people don't count. He and his fellow explorers punished the natives by cutting off their ears and their noses." I can tell my son cannot imagine a world where people's body parts are cut off. He can't handle movies or books with any sort of drama. He'd rather study dinosaur facts and the Jurassic period.

I wonder: Did Falconer know that 'The Age of Discovery' of Columbus was the beginning of mass genocide? For discovery and curiosity is one thing, but brutality in the name of discovery is another. Because Falconer was capable of changing his mind, I believe that if he had he learned about the brutality of Columbus, he would not have named the mammoth after him.

For most of his life, Falconer believed in creationism. He believed that nature, the universe, and humans originated from the supernatural acts of divine creation. After in depth study of the fossil record, Falconer began to contemplate the theory of evolution. When Darwin sent him a copy of *On the Origin of Species* in 1859, he suggested that Falconer would soon realize that species could and have changed over hundreds and thousands of years. This must have been a terrible leap of faith. For generations, scientists have been jeered at, imprisoned, or killed for believing anything other than God created the world in seven days. This leap of faith is the sign of a great man, one who is so curious that he would be open to changing his mind when the data or, as in this case, the fossil record proved him wrong.

"If you haven't heard of Falconer, then who is your favourite palaeontologist?" I have no idea what to expect because I often space out when my son starts spewing fossil facts at me.

"Mary Anning is my favourite palaeontologist. She unearthed *Ichthyosaurus, Plesiosaur, and Pterosaur.*"

My heart soars that my son's favourite paleontologist is a woman.

"Do you know that she barely received credit for her fossil hunting? She wasn't taken seriously because she was a woman and she wasn't wealthy or educated. Can you imagine that? I wonder if Falconer took women scientists seriously?" I ask out loud.

Once again he looks at me confused as he turns the pages of his book to the section about Mary Anning and shows me a sketch that she drew of *Plesiosaur*. This drama of the scientific world astounds him. He just wants the world to be stable and knowable. It's enough for him to create A-Z songs about every dinosaur. It's enough for him to memorize and recite the geological time periods. Like me, he is confused by the constant change in taxonomy, so he searches for the latest copyright dates, with the most up to date information.

But I don't allow him to numb himself with facts. He needs to know the stories that shaped the people who discovered, studied, and named the plants, the animals, and the geography. Many of these scientists like Falconer are unsung heroes of science. Just because they weren't famous, their discoveries were not any less important.

My son continues to tell me about the Columbian mammoth which disappeared from the Americas around 11,500 years ago partly due to hunting pressure and human interaction. "Some of the mammoth fossils are covered in butcher marks for food and some of the bones were used by the native people for tools and shelters."

I wonder once again why the mammoths were named after Columbus instead of after the Native Americans that lived with these ancient elephants? As much as the changing of scientific names drives me crazy, I hope that the species name *columbi* changes one day to a name that honours a Native American scholar or scientist.

Falconer, who lived many years in India, was strongly influenced by Hindu mythology which reveres the elephant. According to Hindu scholars, the elephant head deity, Ganesha, symbolizes the ability to acquire wisdom and knowledge. As I walk through the mountains and search the wet sub-alpine meadows for Elephant's head, I hope that I have taught my son the other lessons that Ganesha symbolizes: curiosity, the patience to listen carefully, and the ability to recognize truth.

About the author

Luca Brite is a Panamanian American author with degrees in biology and Spanish from Western Washington University and a Creative Writing Certificate from UCLAx. She is a Certified Rolfer and Craniosacral Therapist with a passion for writing about bodywork, nature, and magical realism. At present, she is working on her MFA in Creative Writing through Goddard College, Washington State. In 2021, she received an Allegra Johnson Award for an excerpt of her unpublished memoir, 'The Girl Who Was Swallowed by a Boa'.